IMAGES
of America

EAST LAKE VIEW

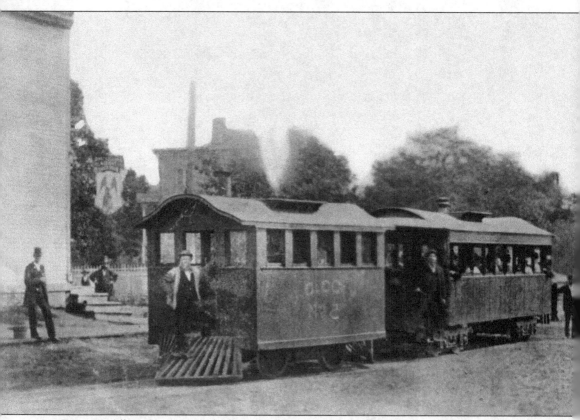

Engineer Albert Street stops the Dummy Road train in the late 1800s on Broadway, then known as Evanston Avenue. The line was called the Dummy Road because the train was pulled by a covered locomotive known as a "dummy" and used on public streets. This line ran from Fullerton Avenue to Irving Park Road and then headed west to Graceland Cemetery. (Courtesy of Lake View Presbyterian Church.)

ON THE COVER: Fans stream away from Wrigley Field on foot, in streetcars, and by automobile in this undated photograph. (Author's collection.)

IMAGES
of America
EAST LAKE VIEW

Matthew Nickerson
Foreword by Alderman Tom Tunney

ARCADIA
PUBLISHING

Copyright © 2017 by Matthew Nickerson
ISBN 978-1-5402-1527-7

Published by Arcadia Publishing
Charleston, South Carolina

Printed in the United States of America

Library of Congress Control Number: 2016953541

For all general information, please contact Arcadia Publishing:
Telephone 843-853-2070
Fax 843-853-0044
E-mail sales@arcadiapublishing.com
For customer service and orders:
Toll-Free 1-888-313-2665

Visit us on the Internet at www.arcadiapublishing.com

This book is lovingly dedicated to my wife,
Liz, and children, John and Julia.

CONTENTS

FOREWORD

Lake View boasts a fascinating and surprising past. It is easy to miss it. The neighborhood remakes itself every day, from new bars and restaurants opening to newcomers migrating from every corner of the country.

I was one of those migrants. A South Side native, I moved to Lake View decades ago and ended up buying Ann Sather Restaurant. The woman herself, Ann, taught me, the son of Irish immigrants, how to make Scandinavian dishes. The restaurant, which dates to 1945, helps connect the Swedish past of Lake View (we still serve pickled herring) to the modern neighborhood.

Lake View has a lot of places like Ann Sather, where history lurks while modern life goes on. Places like Barry-Regent Cleaners, founded by a Japanese American who rebuilt her life in Chicago after internment. Places like Broadway United Methodist Church, which rose from the ashes of a devastating fire. Even places like Chicago Tattooing, which lays claims to the title of Chicago's oldest tattoo shop.

The history of Lake View lies under what it is today: a neighborhood that is always evolving, but one that will not forget where it came from.

—Alderman Tom Tunney
2016

ACKNOWLEDGMENTS

A history book is like a brick. It fits into the bricks that have been laid for millennia. The brickmakers, like historians Thucydides, Tacitus, and Tocqueville, must strive to make each brick solid, so that no matter how insignificant in the larger wall, each brick carries its weight. This thin book about one Chicago neighborhood is a pretty small brick, but I have tried to make it right. I have double-checked every fact I could think of. In choice of words and pictures, I have tried to give everyone a fair shake.

I must pay tribute to the other brickmakers of Lake View. One of these brickmakers, Garry Albrecht, helped me with this book by lending his own images and knowledge of the subject. Some of the past brickmakers include the following who wrote or updated the *Lake View Saga:* Stephen Bedell Clark, Philip L. Schutt, Patrick Butler, Bill Breedlove, and Wayne Allen Salle. I also made great use of stories from the *Chicago Tribune,* the *Sun-Times,* DNAinfo, and the work of Chicago historian Geoffrey Baer. Another valuable resource was the *Encyclopedia of Chicago,* edited by Janice L. Reiff, Ann Durkin Keating, and James R. Grossman.

The most valuable—actually, invaluable—resource was the photographic contributions of the people, businesses, and institutions of Lake View. The more than 200 pictures in this book came in great part from Lake Viewers, past and present. Many photographs also came from Chicago's wonderful small archives. The images I used are at North Park University, the Swedish American Museum, the Japanese American Service Committee, the Gerber/Hart Library, and the Sulzer Regional Library. Thanks go to the Illinois Historic Preservation Agency and the Library of Congress.

A thank-you is given to the Chicago Cubs, and I acknowledge that Chicago Cubs trademarks and copyrights are used with permission of Chicago Cubs Baseball Club, LLC.

Finally, a warm thank-you goes to the Arcadia Publishing staff and Lake View alderman Tom Tunney.

INTRODUCTION

The story of East Lake View starts with Lake View House. The summer resort opened in 1854 near Sheridan Road and Grace Street—north of Chicago at that time. Visitors fleeing cholera flocked to the hotel, which offered a view of Lake Michigan. Lake View House became the neighborhood's first tourist attraction. It would not be the last.

Lake View, first a township then its own city, by the 20th century had become a bustling Chicago neighborhood. On the lakefront, rich residents had replaced rich hotel guests. Along Lincoln Avenue, Germans had settled in droves. Squeezed in between was a colony of Swedes on Clark Street. We see this pattern today: luxurious high-rises on the lake, Dinkel's on Lincoln Avenue, and Ann Sather in the middle.

The German world of Lincoln and Southport Avenues is chronicled in another Arcadia Publishing book, *Lake View*. This book, *East Lake View*, presents the world of Clark Street, Halsted Street, Broadway, and Lake Shore Drive. Lake View's traditional north and south borders, Irving Park Road and Diversey Parkway, will hold for this history. It might seem overkill to write two books on Lake View, but east and west are very different neighborhoods!

Affluent Lake View and blue-collar Lake View coexisted happily for many decades. High-rises rose on Lake Shore Drive. Inland, ethnic Lake Viewers enjoyed the benefits of steady factory work and a respectable neighborhood. For entertainment, Wrigley Field beckoned.

Lake View's stability fractured in the 1960s as residents moved away. Rents dipped west of Broadway, and the streets turned seedy. The Swedes flooded out. They often were replaced not by immigrants, but by an unusual mix of Americans on the move. American Indians from around the Great Lakes arrived, sometimes pushed by federal policy. Southerners joined them, to jokes about hillbillies. Japanese Americans found more jobs and less prejudice in Lake View. Puerto Ricans and Mexicans joined the migration.

East Lake View by the 1970s was tough. The Latin Eagles stalked the streets. Even as Lake Shore Drive's denizens shrunk from crossing Broadway, signs emerged of economic revival. Young professionals moved north from Old Town to what they were told was now New Town. By the lake, promoters touted Belmont Harbor. The area turned hip and then gentrified so fast that some predicted the scene's death. "Is tuned-in, turned-on New Town on the way out?" the *Chicago Tribune* asked in 1973. The question was premature, but the writing was on the wall, and it was not gang graffiti.

East Lake View came full circle in the nineties. The onetime resort again was a destination. For many, the destination was Wrigley Field—or the bars around it, dubbed Wrigleyville. Guys reliving fraternity days jammed Hi-Tops and Sluggers. Two blocks east of the crowded sports bars were crowded gay bars. Halsted Street was dubbed Boystown, giving East Lake View, or a section of it, yet another name to go by.

Today, real estate sellers do not need to make up any more euphemisms or substitutes for "Lake View." The name sells itself. Lake View is elite, entertaining, and above all, expensive.

The affluence of Lake View can mask its history, but the past is always present. Take a look at 3257 North Sheffield Avenue. The brick-and-stone building holds a century of history. Today, it contains expensive apartments—modern East Lake View. In the eighties, it was the home of Medusa's—alternative East Lake View. In the sixties, it housed the Japanese American Service Committee—Japanese East Lake View. In the thirties, it was the clubhouse of the Independent Order of Vikings—Swedish East Lake View.

Look high up, nearly to the building's top. You can see an etched Viking ship, plowing through stone waves, reminding us of who once walked our streets.

One

AT WORK IN
EAST LAKE VIEW

Going to work in Chicago neighborhoods meant, for many years, trudging to the factory. East Lake View, though, never had a lot of industry. Going to work often meant heading to the Loop on the L train, just as it does today.

For those who did work in East Lake View, a likely job was at sprawling Illinois Masonic Medical Center. The hospital's roots date to 1901, making it one of the oldest institutions in the neighborhood. Two of its rivals for oldest employer are Central Federal Savings & Loan Association and Torstenson Glass, both founded in the 19th century by Swedes.

These days, working in East Lake View increasingly means at a restaurant or a bar. New establishments pop up on Clark Street and Broadway every month, but a few survivors have resisted the trends, or adapted to them. As of 2017, El Jardin, Yak-Zies, and L&L Tavern all are members of the five-decade-old club.

Speaking of bars, East Lake View boasts a lot of them. Clark Street and Halsted Street rank among the top five streets in Chicago with the most taverns. The variety is a thing to behold. East Lake View has sports bars (see the Wrigleyville chapter), gay bars (see the Boystown chapter), dive bars (see L&L in this chapter), and yuppie bars (walk down any street). There are even holes-in-the-wall like Joe's on Broadway. The 3563 North Broadway establishment has no theme, brand, or corporate parent. Joe's marked its 40th birthday in 2016, and regular Bob Lane likened it to a famed, fictional Boston bar. "It's the 'Cheers' of the neighborhood," he said. No matter how much East Lake View has changed, there's still such as thing as a friendly, neighborhood tavern.

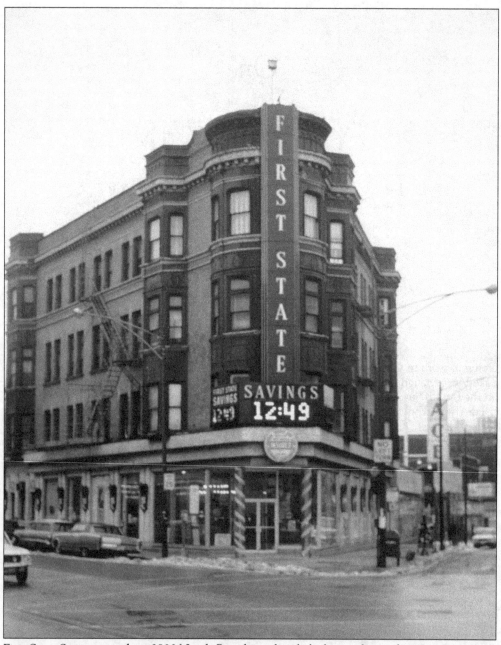

First State Savings stands at 2800 North Broadway shortly before it changed names. First State merged with an old Lake View bank, Central Federal Savings & Loan Association, in 1972. (Courtesy of Central Savings.)

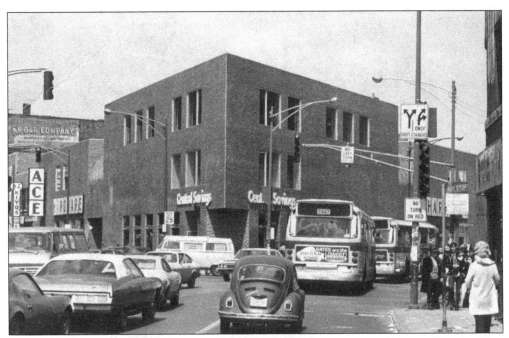

Central Savings remodeled First State's 2800 North Broadway building after the 1972 deal that brought them together. A Borders bookstore later moved here. On the corner now is a gigantic Walgreens, while Central Savings is up the street. (Courtesy of Central Savings.)

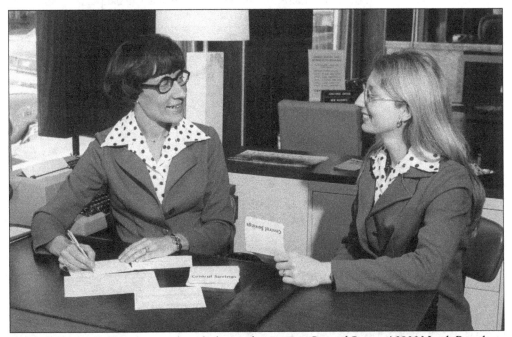

Betty Kirchberg (left) and an unidentified coworker meet at Central Savings' 2800 North Broadway branch. Central Savings was originally a Swedish immigrant bank located downtown, hence the name "Central." Today, the bank is headquartered at Belmont and Ashland Avenues. (Courtesy of Central Savings.)

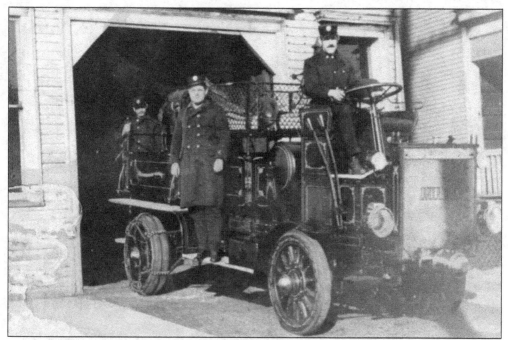

This is how the Wrigley Field firehouse looked a century ago. The wooden firehouse was built in 1884 near Belmont Avenue and Clark Street, but 10 years later, the company moved to 1052 West Waveland Avenue, where it is seen in this photograph. In 1915, the fire department replaced the wooden structure with the brick house that stands today outside the ballpark. (Courtesy of Engine No. 78.)

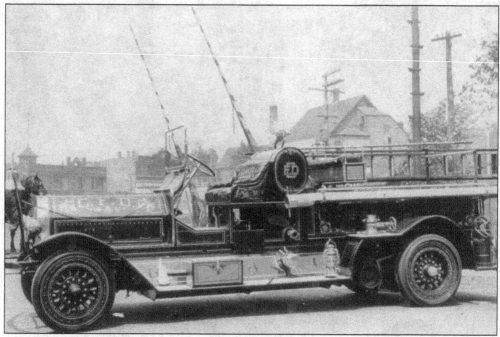

The Wrigley Field firehouse's official name is Engine No. 78. In this 1920 photograph, the engine sits on Waveland Avenue. Note the horse in the background. (Courtesy of Engine No. 78.)

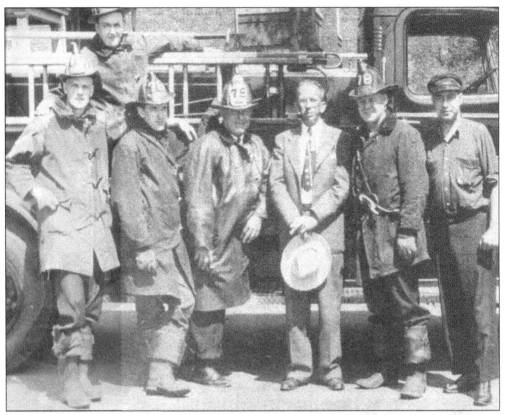

Engine No. 78 firefighters pose in this undated photograph. (Courtesy of Engine No. 78.)

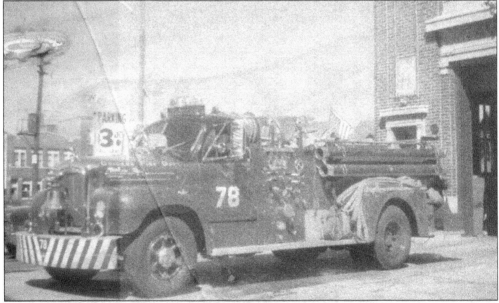

Parking at Wrigley Field was $3 around 1970, when this photograph of Engine No. 78 was taken. Today, tourists from all over the world visit Engine No. 78. The narrow, one-engine house attracts questions like, "Is this a real firehouse?" (Courtesy of Engine No. 78.)

Fire captain John Gruber, a native Lake Viewer, works at Engine No. 55 at Diversey Avenue and Halsted Street. His father, Richard Gruber, worked at Engine No. 55 and would let young John stay overnight in the firehouse. John has spent most of his 37 years as a fireman at Engine No. 55 and likes working on his home turf. "I'm kind of like a creature of habit," he says. (Photograph by author.)

Current and former firefighters gather at Engine No. 55 for the retirement of legendary Battalion No. 5 chief Ed Porter in 2008. Battalion No. 5 includes the four engine companies that cover Lake View, including Engine No. 55 at Diversey Avenue and Halsted Street and Engine No. 78 outside Wrigley Field. (Courtesy of Engine No. 55.)

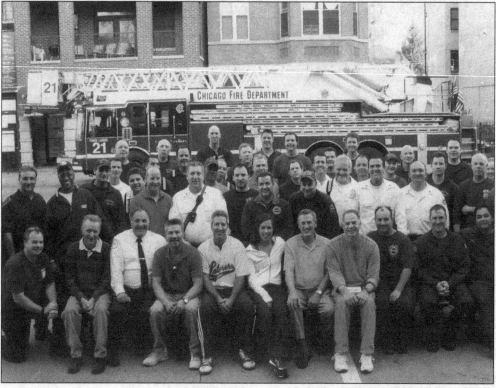

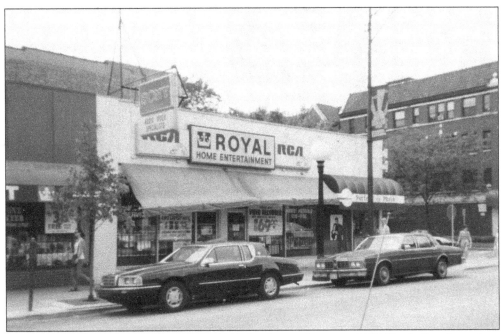

Royal Home Entertainment, seen about 1990, has been a fixture at 2923 North Broadway since 1980. Joe DeGuide and his brother John opened the original store in 1971 on Wilson Avenue in Uptown. In the early years, they sold 45s left over from jukeboxes, used televisions, and an assortment of bongs, roach clips, and "snow seals." (Courtesy of Royal Home Entertainment.)

Royal Home Entertainment at one point also had a store at 3559 North Broadway, seen around 1981. "Video" on the sign refers to long-forgotten CEDs, a type of video disc. Royal has survived after more than four decades by shifting to services like custom installations and selling online. (Courtesy of Royal Home Entertainment.)

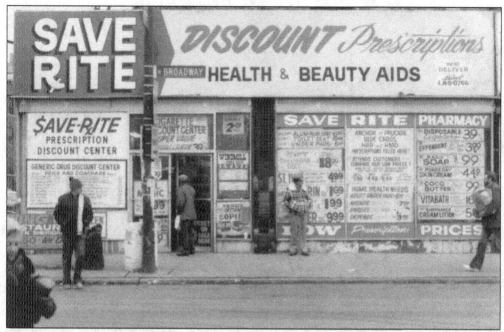

This scene outside Save-Rite pharmacy at 3479 North Broadway definitely looks like the 1970s. The LA-5 phone number on the sign in the top right suggests an even earlier era. But the ad for Dick Gregory's Bahamian Diet for $18.99 betrays that this picture was taken no earlier than 1984, when the diet debuted. (Courtesy of Jim Kolar.)

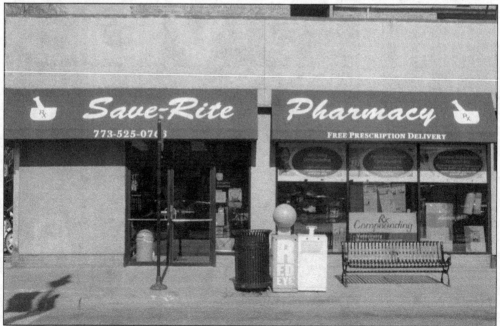

The 3479 North Broadway site, seen today, has been the location of a pharmacy since at least the 1920s, when one of the stores from the Masor's drug chain was there. Then, there was Kramer drugstore. Next, there was Save-Rite, owned by someone named Adler and, today, owned by Jim Kolar. (Photograph by author.)

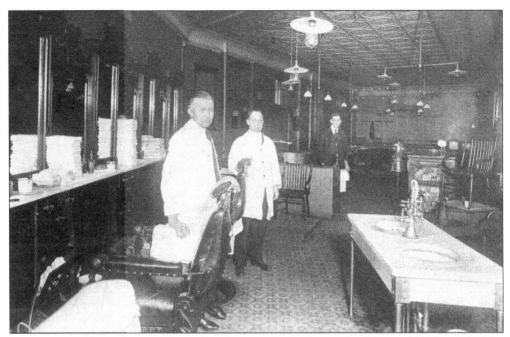

This Clark Street barbershop looks a lot like the barbershops of today—only better. Note the cigarette display case and shoeshine stand on the right, behind the sinks. In the back, there is a billiard table. This photograph was taken in 1911 on Clark Street near Roscoe Street. (Courtesy of Sulzer Regional Library, Chicago Public Library, RLVCC 1.37.)

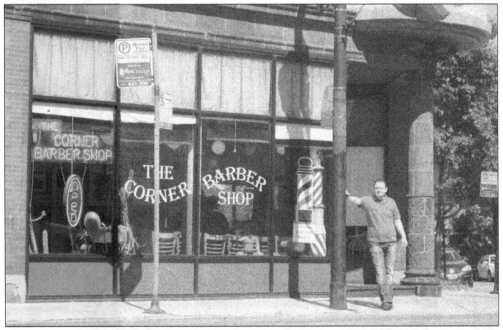

Artur Szewczyk takes a break outside his Corner Barber Shop, located at 2929 North Clark Street. He bought the shop in 2015, continuing a haircutting tradition at that location that stretches back, he believes, to 1913. "We claim it is the oldest shop in the city," he said. (Photograph by author.)

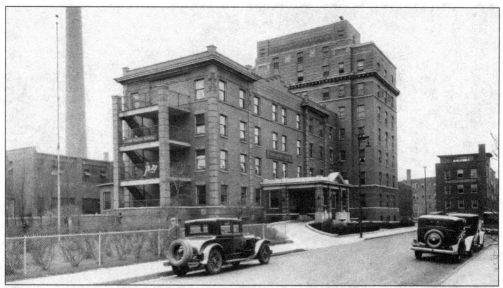

Illinois Masonic Medical Center began in 1921 as a hospital dedicated to serving Masons. The owners took over the Chicago Union Hospital at 834 West Wellington Avenue, which had been founded 20 years before. Note the patients or doctors in white on the porch in this 1933 photograph. (Courtesy of Advocate Illinois Masonic Medical Center.)

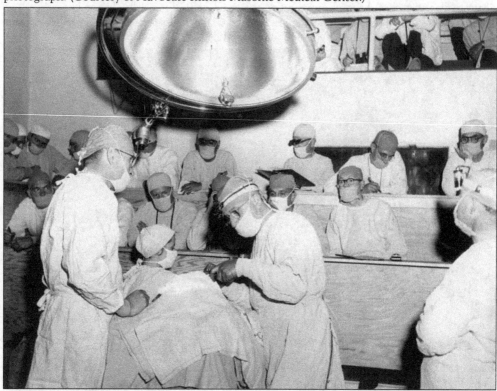

An Illinois Masonic doctor teaches a class in reconstructive nasal surgery in 1952 as more than 60 colleagues watch from around the country. In the 1950s, Illinois Masonic surgeons were operating more than 6,000 times a year. (Courtesy of Advocate Illinois Masonic Medical Center.)

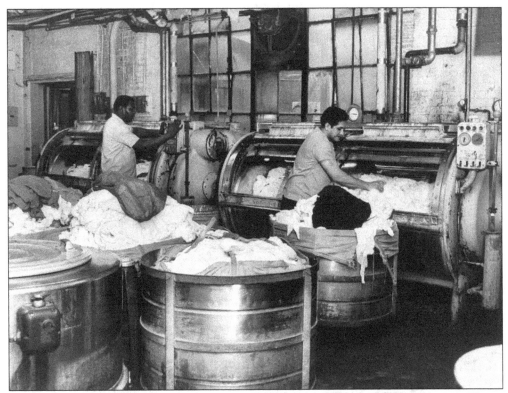

The laundry department does its work in 1964 at Illinois Masonic. (Courtesy of Advocate Illinois Masonic Medical Center.)

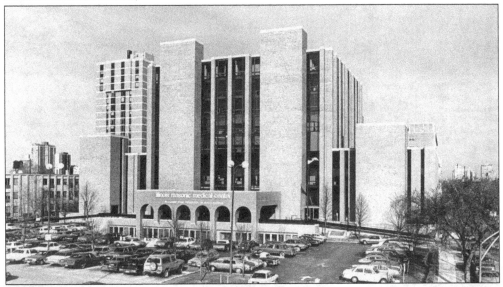

Illinois Masonic's Stone Pavilion was dedicated in 1973. This view shows the west wall of the building, which was named after insurance magnate W. Clement Stone, who donated $4.75 million. The hospital today is vastly different. It has added buildings to its campus along Wellington Avenue and is part of the faith-based Advocate network. (Courtesy of Advocate Illinois Masonic Medical Center.)

The New Modern Grill, despite its name, has not changed much since the 1980s, when this photograph was taken. Passersby may notice the initials "JPM" laid in colorful tile in the entranceway of the restaurant, 3171 North Halsted Street. It is believed they are the initials of the building's developer. (Courtesy of New Modern Grill.)

Shortly after he bought the restaurant in 1988, New Modern Grill owner Harry Karountzos (right) and a worker pause in the kitchen. Karountzos has owned several diners around East Lake View. His thinking? "Everybody's got to eat!" (Courtesy of New Modern Grill.)

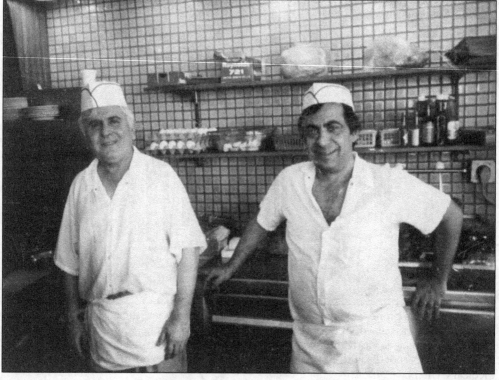

Chris Karountzos pauses outside the Monterey Restaurant at Broadway and Roscoe Street in the 1990s, when her father, Harry Karountzos, owned the place. The space is now occupied by Shiawase, a sushi restaurant. (Courtesy of New Modern Grill.)

The Super Bowl Grill was yet another of Harry Karountzos's greasy spoons. He ran the restaurant in the 1970s and 1980s on Clark Street just south of Diversey Parkway. The grill was between Paris Inn, which was a Cantonese restaurant, and LensCrafters, which is still there. (Courtesy of New Modern Grill.)

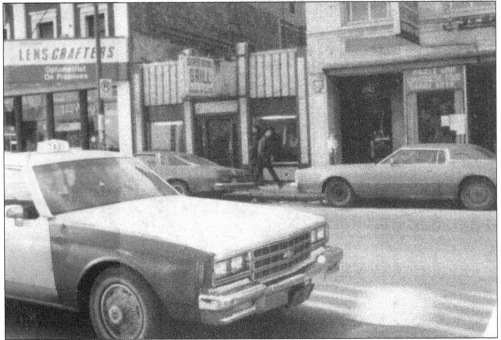

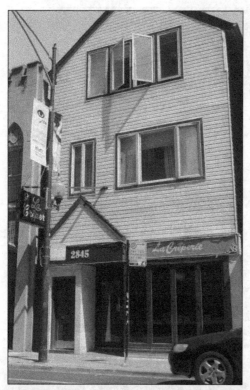

Frenchman Germain Roignant opened La Crêperie in 1972 at 2845 North Clark Street. There were few restaurants specializing in crepes, so he figured he would go where the competition was not. Business in the heat-starved space moved slowly until the *Sun-Times* published a story about the new restaurant. Customers flooded in, and La Crêperie was off and running. (Photograph by author.)

Roignant serves his wife, Sara, in La Crêperie's early days. She died in 2002, and their son Jeremy died in 2013 just as Roignant was closing La Crêperie after four decades. Roignant moved back to France, but decided to reopen La Crêperie months later, this time in partnership with the owners of the Duke of Perth restaurant. Now nearing 80, Roignant will not slow down. His secret? "Soup, salad, and sex." (Courtesy of Germain Roignant.)

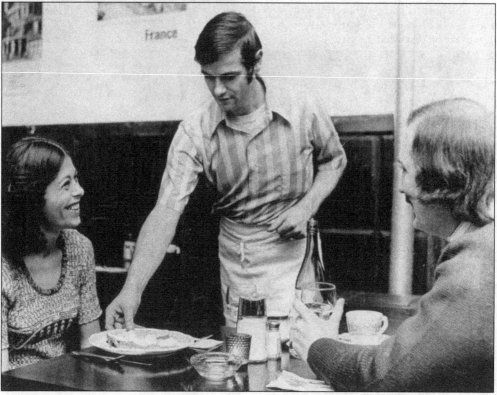

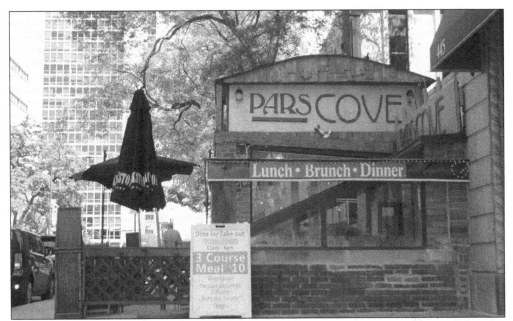

Pars Cove restaurant has been a mainstay at 435 West Diversey Parkway since 1985, when it branched from its original location on the Northwest Side. It was perhaps the first Persian restaurant in Chicago, and it focused on fish, hence the last part of the restaurant's name. The first part of the name came from the owner, Max Pars, an Iranian who was studying economics in Chicago when he fell into the restaurant business. (Photograph by author.)

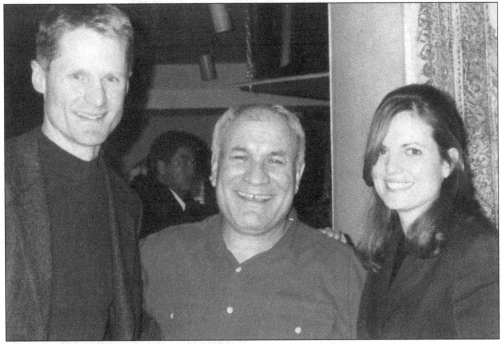

Chicago Bull Steve Kerr and his wife, Margot, pose with Max Pars (center) after a meal at Pars Cove during the 1990s championship years. Kerr, whose father was assassinated while president of the American University of Beirut, grew up in the Middle East. (Courtesy of Pars Cove.)

Nancy's Pizza in the 1980s, seen here, looked a lot like it does now. One thing was different, though, for the restaurant at 2930 North Broadway. Back then, Nancy's had a peep show as a neighbor, as can be seen by the "Open 24 HRS" sign in the small window. The street scene on Broadway, co-owner Harry Anastos recalls, "was like a second Rush Street. We had everything, but never trouble." (Courtesy of Nancy's Pizza.)

Pictured in the 1970s with a television newsman, Nancy and Rocco Palese originally owned Nancy's Pizza on Broadway. Nancy and Rocco sold the restaurant to Harry and Dimitri Anastos, but it is still considered a legacy location of the Nancy's Pizza chain. (Courtesy of Nancy's Pizza.)

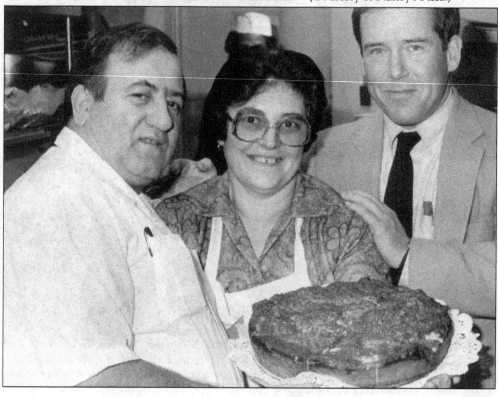

From left to right, Harry Anastos clowns around with policeman Paul Alberti and Rocco Palese in the 1980s at Nancy's Pizza. (Courtesy of Nancy's Pizza.)

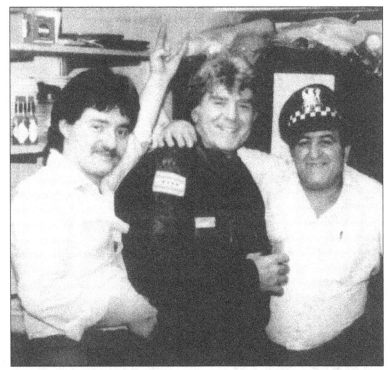

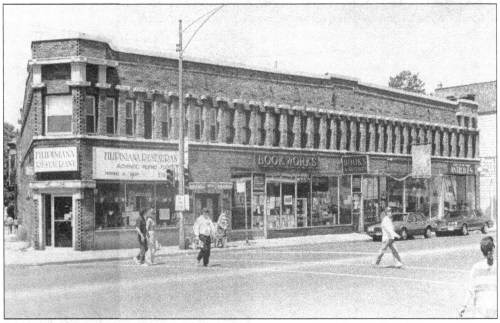

This 1989 photograph of the now-shuttered Filipiniana Restaurant at Clark and Newport Streets is a reminder of Lake View's Filipino Americans. The group's numbers were never large, but they helped build the José Rizal Heritage Center at 1332 West Irving Park Road. A bust of Rizal, a national hero, stood for years outside the center until revelers stole it after the Chicago Blackhawks' 2015 championship victory. (Courtesy of Sulzer Regional Library, Chicago Public Library, RWK15.8.)

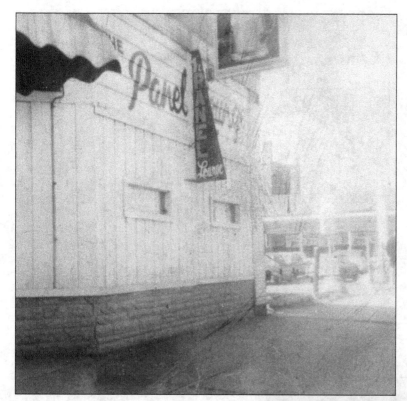

In 1970, Angelo Como and two partners converted the Panel Lounge, 3010 North Broadway, into a tavern called Friar Tuck. Why name it after Robin Hood's friend, the tipsy monk? "I wanted a place where girls felt safe," Como said. A monk was safe. (Courtesy of Friar Tuck.)

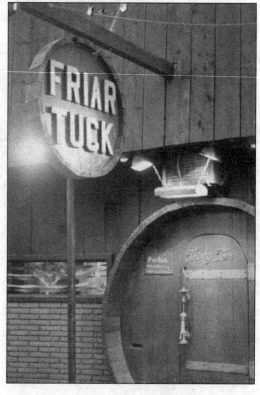

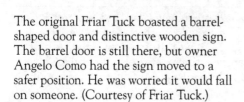

The original Friar Tuck boasted a barrel-shaped door and distinctive wooden sign. The barrel door is still there, but owner Angelo Como had the sign moved to a safer position. He was worried it would fall on someone. (Courtesy of Friar Tuck.)

This is Lake View's most menacing bar: L&L Tavern. The 3207 North Clark Street establishment is run-down on the outside and grimy on the inside. L&L also was the purported cruising ground of two serial killers. Current owner Kenn Frandsen says he was at L&L when Jeffrey Dahmer was arrested and recalls customers recognizing him as a regular. Frandsen also says that the previous owner swore that John Wayne Gacy hung out at L&L. (Photograph by author.)

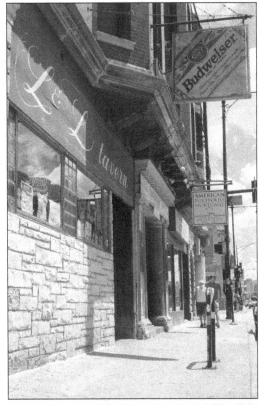

Paul Gillon owned L&L, then called Columbia Tavern & Liquors, in the 1960s. He was one of two early proprietors who found themselves victims of attacks. In 1961, robbers bound, gagged, and held lighted matches to Gillon's back. In 1950, then-owner Marshall Tallaksen was hit in the eye in a drive-by shooting. By the way, why is the bar called L&L? In the 1980s, it was owned by Lauretta Magidson and Lefty Miller. (Courtesy of Kenn Frandsen.)

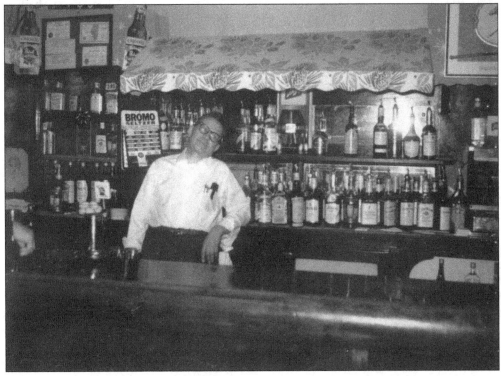

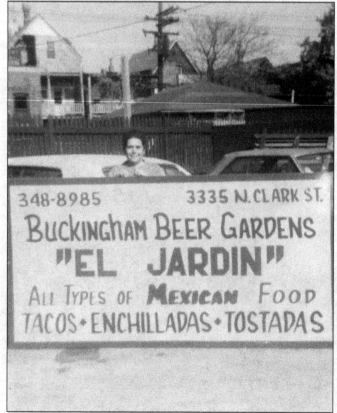

One of Lake View's oldest restaurants is El Jardin, founded in 1967 at 3335 North Clark Street. Three Mexican immigrant sisters—Elizabeth Ortiz, Maria Quinones, and Eudelia Rivera—were running the establishment as a bar but then one day decided to serve tacos. The tacos sold out, and Ortiz quit her factory job the next day to become a full-time restaurateur. (Courtesy of El Jardin.)

El Jardin originally was a Swedish establishment called Buckingham Beer Gardens. Owners Elizabeth Ortiz, pictured, and her sisters recast the name in Spanish and came up with a new sign. Their telephone number was their pay phone's. (Courtesy of El Jardin.)

Elizabeth Ortiz's son Mike pauses outside El Jardin. Still humble in 1971, El Jardin rented its wall to a rival eatery, Franksville. (Courtesy of El Jardin.)

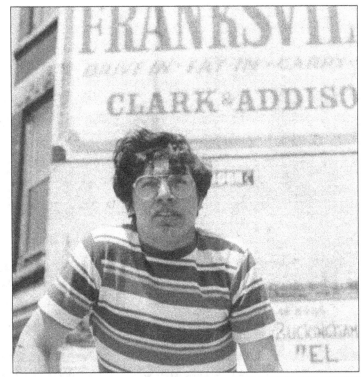

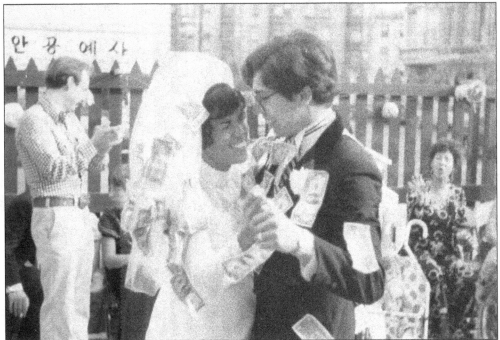

Mike Ortiz held his 1974 wedding reception at his family's restaurant, El Jardin. Mike is part of the second generation that has seen El Jardin evolve from serving Mexican workers to catering to an increasingly affluent neighborhood. A third generation hopes to take over. (Courtesy of El Jardin.)

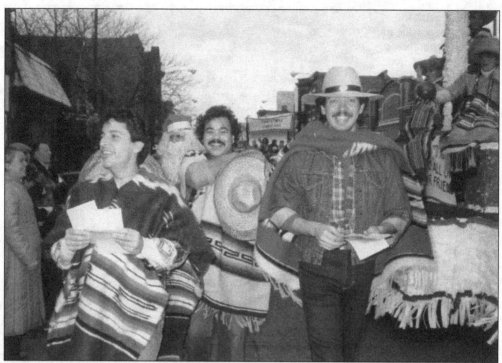

El Jardin marches in the 1982 Lake View Christmas parade. From left to right, friend Joe Papaccio joins El Jardin family members Gus Quinones and Joe Ortiz. (Courtesy of El Jardin.)

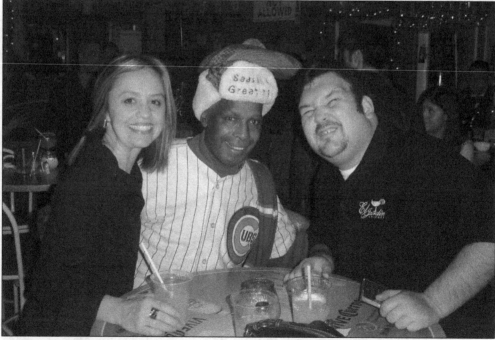

Hey, look who dropped by El Jardin. It is irrepressible Ronnie "Woo Woo" Wickers. The Cubs' most famous fan, known for wearing his uniform and uttering his namesake phrase, frequents El Jardin quite a bit. (Courtesy of El Jardin.)

Two

AT SCHOOL IN
EAST LAKE VIEW

One of the few histories of the neighborhood, the *Lake View Saga*, boasts that "from the earliest days, Lake View had a school system comparable to any in the country." That, indeed, sounds like a boast, but Lake View certainly could brag about its aggressive school building program at the end of the 19th century.

When Lake View Township was independent of Chicago, the school board built eight elementary schools. Among them was School No. 1, which stood at Broadway and Aldine Avenue, where Nettelhorst Elementary is today. School No. 3 stood at Ashland and Wrightwood Avenues, where Prescott Elementary is today. School No. 6 stood at School Street and Clifton Avenue, where Hawthorne Scholastic Academy is today.

More than a century later, the efforts of Lake View's founders still are paying off. Many of Chicago's best public schools reside in the neighborhood, a change from the rough-and-tumble 1970s and 1980s. Hawthorne Scholastic Academy, a magnet school with many Lake View students, ranked recently among the top 10 highest-scoring city schools. Nettelhorst, energized by mothers who insisted on improvement, is another high performer. East Lake View is a well-schooled neighborhood.

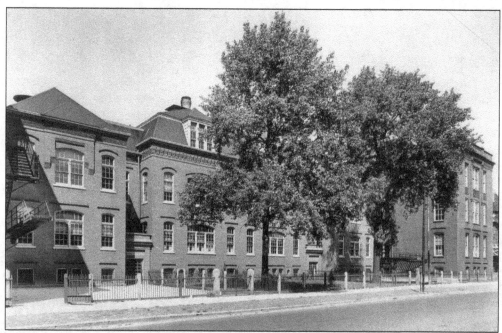

Hawthorne Scholastic Academy originally was called Lake View School No. 6 and housed in this building, which faces School Street east of Clifton Avenue. The school was built in 1880, when Lake View was independent from Chicago. After Chicago swallowed Lake View, the school was renamed in honor of author Nathaniel Hawthorne. (Courtesy of Hawthorne Scholastic Academy.)

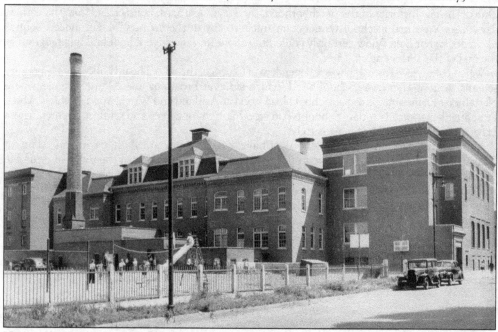

Here is a look at the original Hawthorne from the back. This school was almost entirely torn down in the 1950s. The auditorium and gym wing (far right), which face west onto Clifton Avenue, was left standing. The current school was built by adding to the north side of the surviving wing. (Courtesy of Hawthorne Scholastic Academy.)

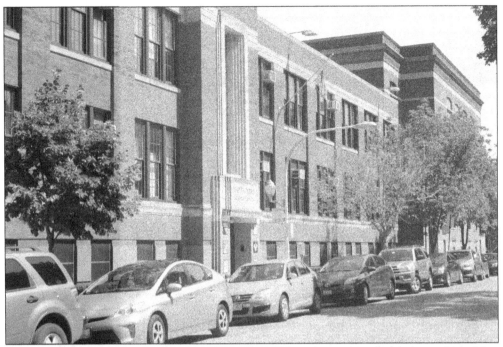

Hawthorne Scholastic Academy today is located on Clifton Avenue, creating a geographic oddity. School Street, which was named after Hawthorne, no longer has the school on it. (Photograph by author.)

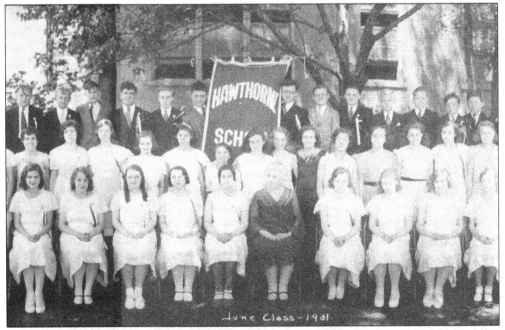

A member of the Hawthorne class of 1931 visited the school several years ago and donated this photograph of him and his well-dressed schoolmates. This image only captures the center of the original picture, which is panoramic and extends far to the right and left. (Courtesy of Hawthorne Scholastic Academy.)

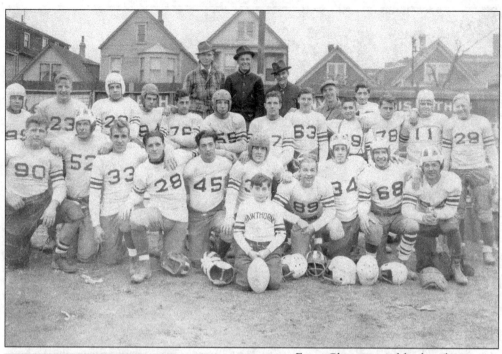

Every Chicago neighborhood once had an athletic club, often named after a local school. Young men, like these Hawthorne football players, would organize teams and play other amateur clubs. The most famous club was the South Side's Hamburg Athletic Club, whose manager was Richard J. Daley. (Courtesy of Hawthorne Scholastic Academy.)

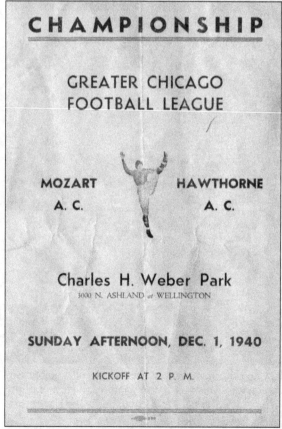

CHAMPIONSHIP

GREATER CHICAGO FOOTBALL LEAGUE

MOZART A. C.

HAWTHORNE A. C.

Charles H. Weber Park
3000 N. ASHLAND at WELLINGTON

SUNDAY AFTERNOON, DEC. 1, 1940

KICKOFF AT 2 P. M.

Games between neighborhood athletic clubs were a big deal, as the existence of this program shows. This game was announced in the *Chicago Tribune*, which noted that Mozart was the defending champion. For a long time, Hawthorne enjoyed a rivalry with a team closer to home, the Wizards from the Agassiz Elementary School playground. (Courtesy of Hawthorne Scholastic Academy.)

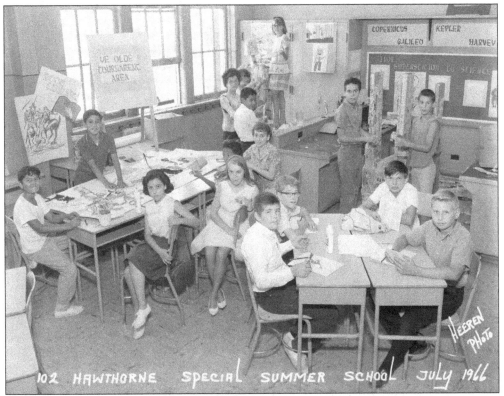

Students at a Hawthorne summer program in 1966 studied medieval knights and Renaissance scientists. (Courtesy of Hawthorne Scholastic Academy.)

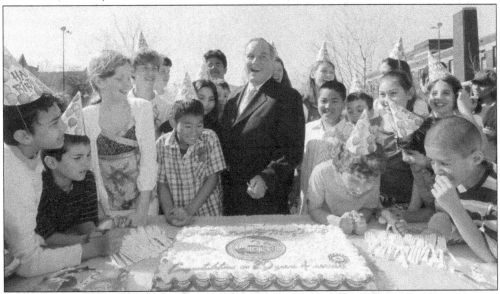

Pictured at Hawthorne in 2009, Mayor Richard M. Daley celebrates his 20th year in office. Hawthorne, a top-scoring magnet school, has drawn the favor of politicians over the years. Gov. James Thompson sent his daughter there in the 1980s, and Ald. Patrick O'Connor's children also attended. (Courtesy of Hawthorne Scholastic Academy.)

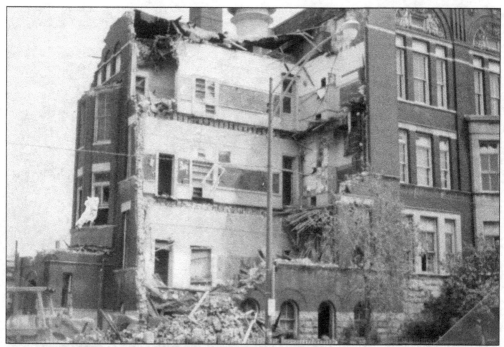

Horace Greeley Elementary School, 3805 North Sheffield Avenue, was closed in 1978 and torn down. Textbooks in hand, students walked over to their new building at 832 West Sheridan Road. The old Greeley, besides being run-down in its waning days, was noisy. Elevated trains ran behind the school, cheers from Wrigley Field wafted over it, and the gym's location on top of the library made it hard to read. (Courtesy of Phyllis Weinstein.)

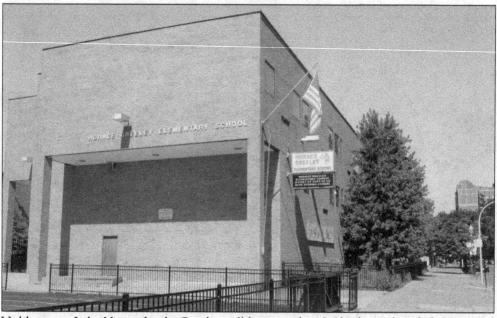

Unlike many Lake View schools, Greeley still has a student body that is largely low-income. However, 39 percent of students in 2016 met or exceeded expectations on state tests, more than the Illinois average. (Photograph by author.)

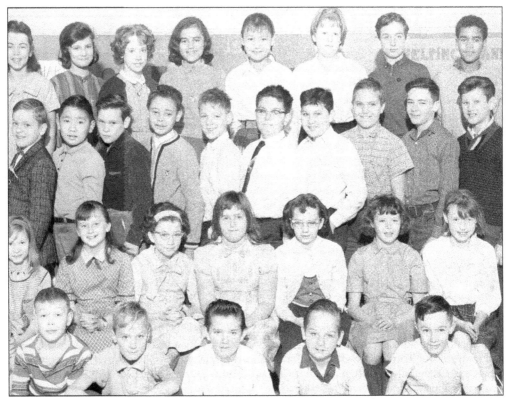

This is longtime Greeley teacher Phyllis Weinstein's first class. She started teaching at age 20 and was startled to find a 15-year-old boy in her sixth-grade class. Many of the students came from poor Southern families, she recalls, and were noticeably grateful for the education they were getting. Below is Phyllis Weinstein's last class at Greeley. She spent 34 years at the school, teaching social studies and language arts, working in both buildings. "I grew up there," she says. (Both, courtesy of Phyllis Weinstein.)

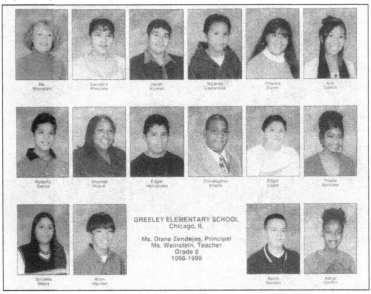

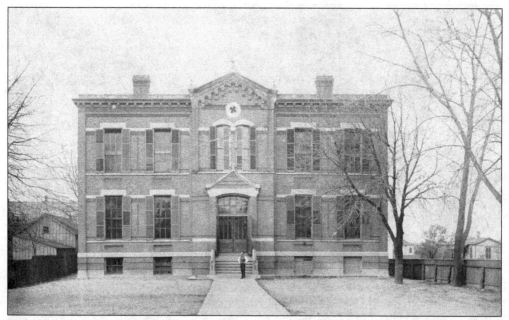

Welcome to Lake View School No. 1. This school stood in the 1880s at Broadway and Aldine Avenue, now the site of Nettelhorst Elementary School. Lake View No. 1 once bore the unfortunate nickname of the "Dummy Road School," after Broadway, which was known as the Dummy Road because of the dummy train that ran on the street. (Courtesy of the Chicago Public Library, Sulzer Regional Library, RLVCC 1.970.)

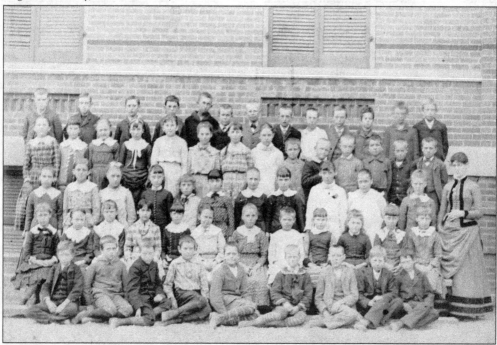

Teacher Jessie Ferguson poses with her Lake View School No. 1 class in 1878. One of the girls in the second row, Margaret E. Kane, donated this photograph, but failed to note her exact location. (Courtesy of Chicago Public Library, Sulzer Regional Library, RLVCC 1.1078.)

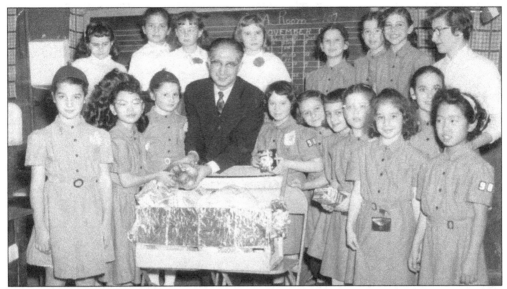

Longtime Louis Nettelhorst Elementary principal William Block poses with Girl Scouts during a food drive. Block served from 1948 to 1978 at Nettelhorst, which was founded in 1893. The school was named after the head of the board of education. (Courtesy of Nettelhorst School.)

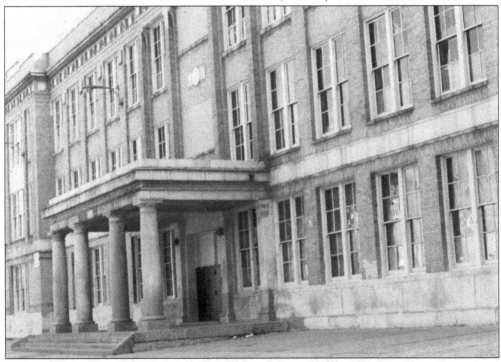

This building at 851 West Waveland Avenue was the longtime home of LeMoyne Elementary School. By the 1980s, the school had grown rough, with "Welcome to Latin Eagles City" written on the playground's entrance. In 2006, the Inter-American Magnet School, which had been housed at the Robert Morris School, moved in. Inter-American, which teaches Spanish and English equally, operates there today. (Courtesy of the Chicago Public Library, Sulzer Regional Library, RLVCC 1.958.)

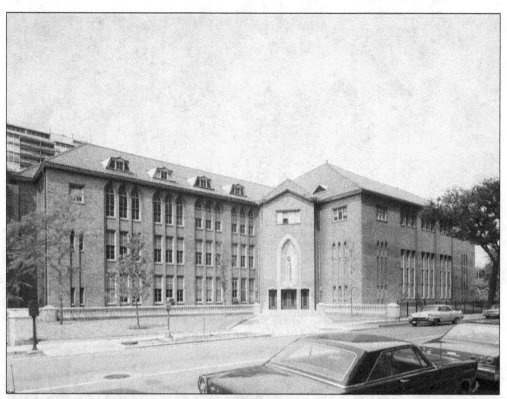

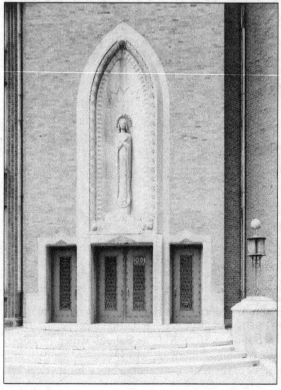

Immaculata High School, seen in 1965, educated Catholic girls for 60 years at 640 West Irving Park Road. In 1981, falling enrollment closed the school, which was made a city landmark. The building was designed by Barry Byrne, who worked under Frank Lloyd Wright before gaining a reputation as an architect who combined modern style with traditional church architecture. The American Islamic College operates on the site today. (Courtesy of Library of Congress.)

A mystery swirled for years around Immaculata High School's Madonna, a one-ton statue that looked over the entrance. When the American Islamic College bought the school in 1982, the statue was removed. Rumors reportedly spread that it had been destroyed, but after decades, it turned up in storage at the University of Chicago. The statue now rests in a Park Ridge museum dedicated to the work of sculptor Alfonso Iannelli. (Courtesy of Library of Congress.)

Three

AT WORSHIP IN EAST LAKE VIEW

East Lake View is a treasure trove of faith. In a city where Catholic churches have traditionally dominated much of the landscape, East Lake View can claim more than a dozen Protestant and Jewish, as well as Catholic, houses of worship. Seekers can find places as traditional as Anshe Sholom, an Orthodox synagogue, or as flexible as Broadway Methodist, which proclaims itself "lesbian, gay, bisexual, asexual, and straight," not to mention "transgender, intersex, female, male, gender fluid." For the deepest questions about life, East Lake View offers many answers.

In the 20th century, East Lake View's cornucopia of beliefs was especially rich for Swedes. One Swedish church after another dotted the streets radiating from Clark Street and Sheffield Avenue. There was something for everyone.

Immigrant Swedes could attend Swedish-language Trinity Lutheran. Swedes who had settled into America could walk to Messiah Lutheran, a congregation that spoke English (yet was still Swedish in heritage). Swedes who rebelled against their traditions could stroll to Lake View Mission Covenant, part of a breakaway denomination (but which still held a Lutheran-like theology). All these churches existed within two blocks of each other. They were not the only Swedish churches, either.

East Lake View's religious geography broke down neatly. West of Halsted was the Scandinavian Lutheran paradise. Running up and down the Broadway corridor was a string of mainline Protestant churches, like Lake View Presbyterian, St. Peter's Episcopal, Second Unitarian, and Broadway Methodist, to serve well-off lakefront residents. As successful Jews joined the WASPs on Lake Shore Drive, a synagogue for each major branch of Judaism opened, creating a run of temples parallel to, and east of, the Protestant churches: Anshe Emet for Conservative Jews, Temple Sholom for Reform Jews, and Anshe Sholom for the Orthodox.

In Chicago, the Catholic Church can never be overlooked, and East Lake View is no exception. Our Lady of Mount Carmel, founded by Irish Americans, calls itself the mother parish of English-speaking Catholic congregations on the North Side. From the 1880s until the 1980s, neighborhood Catholics also could attend St. Sebastian. A fire sealed St. Sebastian's fate, but Mount Carmel thrives today. The church's Gothic-style structure made of Indiana limestone marries medieval and modern on Belmont Avenue, in the heart of East Lake View.

Anshe Emet Synagogue looked much the same during World War II, when this photograph was taken, as it does today. The synagogue was founded in 1873; members met first on the Near North Side, eventually moving to Patterson Avenue near Broadway. In 1926, they bought Temple Sholom's building at Pine Grove Avenue and Grace Street, where Anshe Emet remains. (Courtesy of Anshe Emet.)

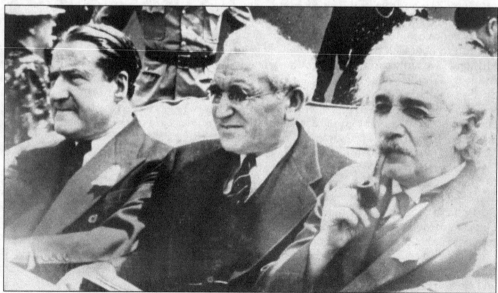

Anshe Emet's Rabbi Solomon Goldman (center) rides with Albert Einstein (right) and Rabbi Stephen Wise at the New York World's Fair that opened in 1939. Goldman had been chosen the year before to head the Zionist Organization of America. Goldman led Anshe Emet from 1929 until 1953, and its history recalls him as a "mighty oak" who packed Friday night services. (Courtesy of Anshe Emet.)

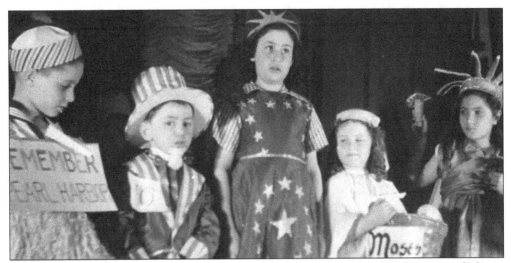

Betejoy Specter holds a bucket with the name "Moses" on it, Joan Kornbluth is the Statue of Liberty, and others join in an Anshe Emet patriotic presentation in 1943. Anshe Emet's contributions to the war effort were stunning: it donated nearly $8 million, more than 550 members served in the armed forces, and 21 men were killed, according to the synagogue's history. (Courtesy of Anshe Emet.)

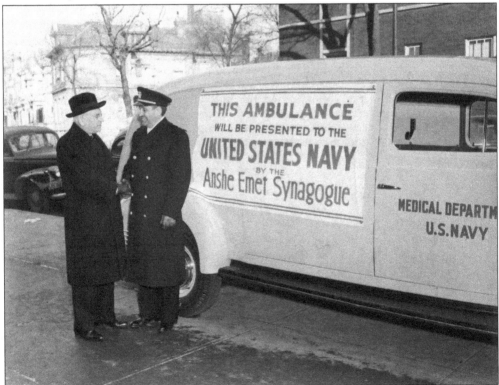

Rabbi Goldman presents Lieutenant Griffin, US Navy, with a gift. Some $2,400 had been set aside for the Anshe Emet Sisterhood's dinner-dance, but it was used instead to buy an ambulance for the Navy. Another fundraising effort led to the naming of a B-17 bomber the *Anshe Emet*. (Courtesy of Anshe Emet.)

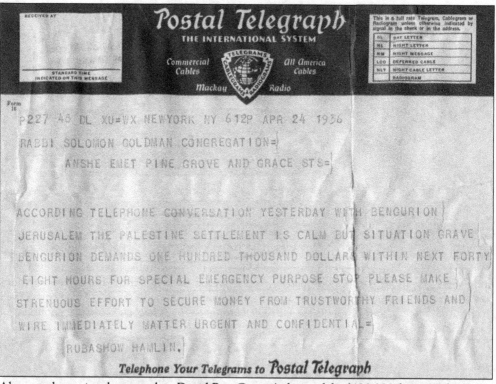

Above, a dramatic telegram relays David Ben-Gurion's demand for $100,000 from Anshe Emet, warning that the situation is "grave" in Palestine. Ben-Gurion, one of Israel's founders, was making the request five days after the 1936 Arab revolt had begun in Palestine, where Jews were trying to build a national home. Pictured below, Ben-Gurion, second from left, Israel's first prime minister, greets kids from the Anshe Emet day school. Ben-Gurion visited Chicago in both 1951 and 1967, each time met by enthusiastic crowds of children. (Both, courtesy of Anshe Emet.)

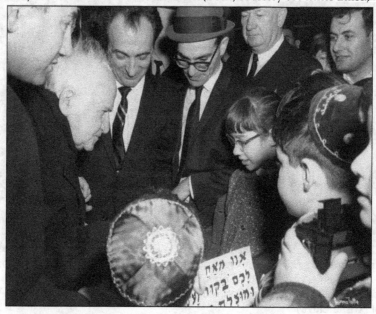

From left to right, Rosalie
Paulsen, Steven Peskin, and
Joseph Pickard celebrate the
High Holidays in 1964 at Anshe
Emet. The synagogue by 2013
had more than 1,100 families,
and its congregation has included
Material Service cofounder
Irving Crown and Cook County
Democratic Party chief Jacob
Arvey. (Courtesy of Anshe Emet.)

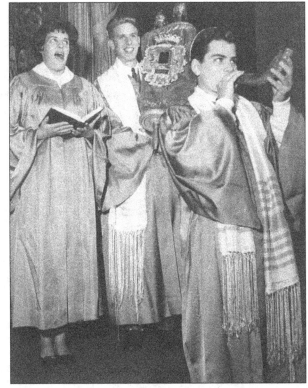

A ceremony marks the ground
breaking for a community building
and school in 1965 for Anshe
Emet, described by the *Tribune*
then as the largest Conservative
congregation in the Midwest.
(Courtesy of Anshe Emet.)

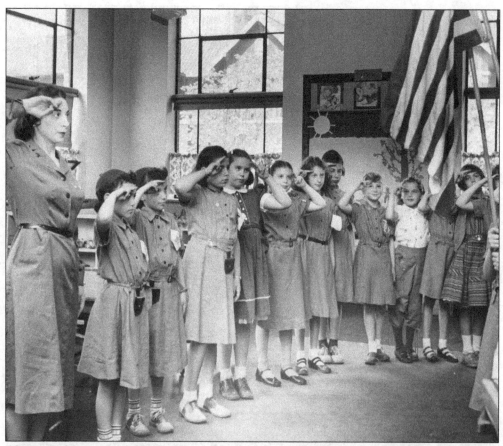

Above, Girl Scouts pay tribute to Old Glory in 1957 at Anshe Emet. In 1946, the Anshe Emet Day School opened with 31 students. Recently, the Bernard Zell Anshe Emet Day School has boasted 500-plus students from nursery school through eighth grade. Below, a Boy Scout attempts to revive a not-so-stricken comrade at Anshe Emet. (Both, courtesy of Anshe Emet.)

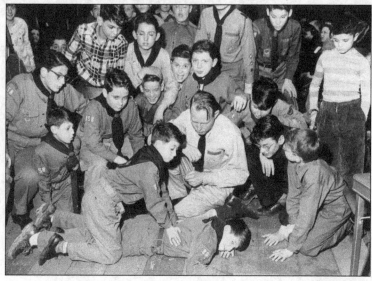

Friendship blooms at Anshe Emet's day camp. A 1955 *Tribune* article reports camp activities including hikes, journalism, arts and crafts, dancing, and motion pictures. (Courtesy of Anshe Emet)

Anshe Emet campers learn the forward crawl. Campers swam twice a week at the Lincoln Turners pool, the *Tribune* article notes. (Courtesy of Anshe Emet.)

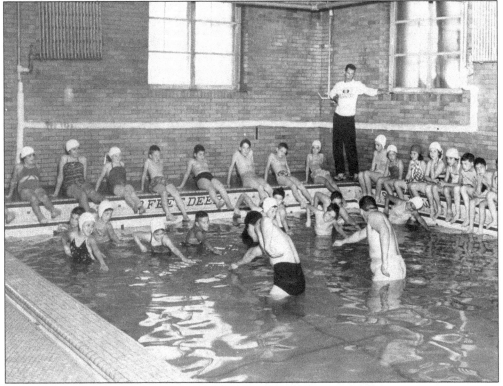

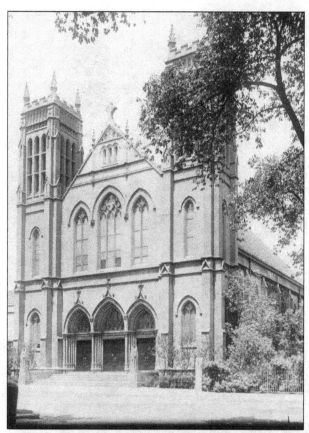

Our Lady of Mount Carmel Catholic Church was founded in 1886. Originally at Wellington Street and Sheffield Avenue, Mount Carmel moved to its current location, 708 West Belmont Avenue, in 1913. This photograph shows Mount Carmel at its golden anniversary in 1936. The church was constructed of Indiana limestone and boasts a pipe organ made by the famed E.M. Skinner. (Courtesy of Our Lady of Mount Carmel Church.)

Mount Carmel celebrates its 50th anniversary as a parish in 1936. Today, the church is still a center for the Catholic faith in East Lake View. It also has been a pioneer in opening its doors to gays, holding Masses since 1990 for homosexual Catholics. (Courtesy of Our Lady of Mount Carmel Church.)

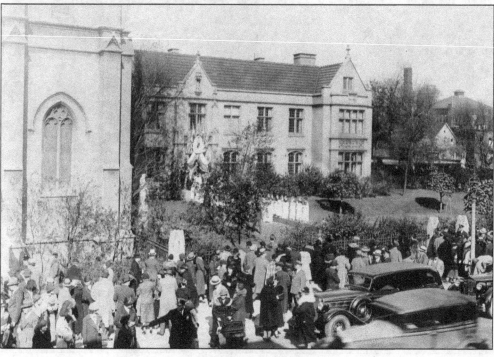

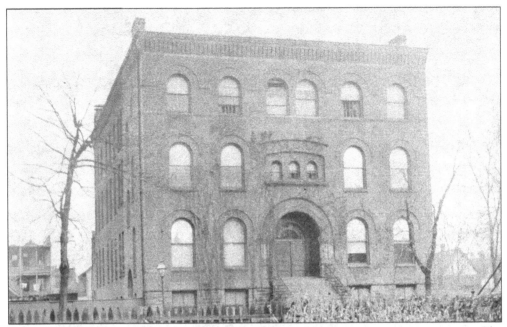

Our Lady of Mount Carmel's school began in 1888 in this building on Belmont Avenue. The school is still there, although with a different facade. Mount Carmel believes it has the oldest school building still in use in the Archdiocese of Chicago. (Courtesy of Our Lady of Mount Carmel Church.)

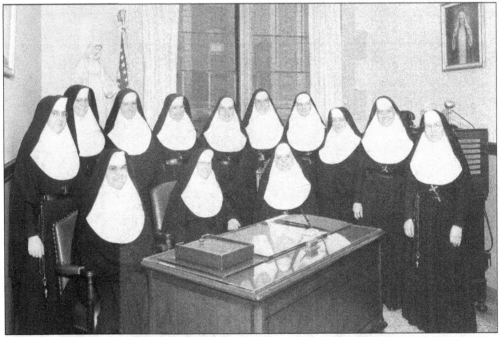

Mount Carmel Academy's faculty poses in 1953. The Sisters of Mercy founded the school, but the era of nuns in the classroom is over. Today, the school, which is preschool through the eighth grade, has more than two dozen teachers, all laypeople. (Courtesy of Our Lady of Mount Carmel Church.)

Here, boys exercise the old-fashioned way. (Courtesy of Our Lady of Mount Carmel Church.)

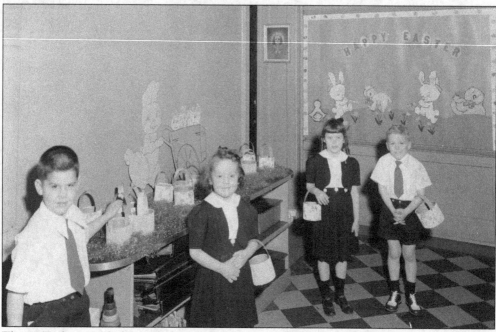

This 1953 photograph shows kindergartners celebrating Easter. (Courtesy of Our Lady of Mount Carmel Church.)

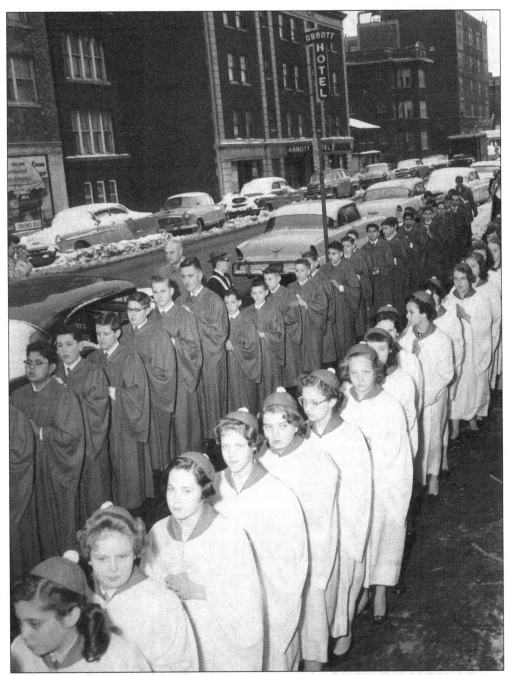

Mount Carmel Academy graduates march down Belmont Avenue in 1960. In the background is the Abbott Hotel, the single-room occupancy hotel that closed decades later. The hotel drew controversy in 1982 when neighbors complained to Mayor Jane Byrne about its drug pushers and prostitutes, the latter of whom were exposing themselves in windows. "What they're seeing across the street, no child should see," said one mother. (Courtesy of Our Lady of Mount Carmel Church.)

The Salvation Army's campus, centered on its distinctive redbrick mansion, sits at Addison Street and Broadway in the middle of East Lake View. The campus contains the College for Officer Training for the Army's central territory. The Salvation Army is a Protestant denomination, with the college a seminary to train its future ministers, known as officers. (Courtesy of the Salvation Army.)

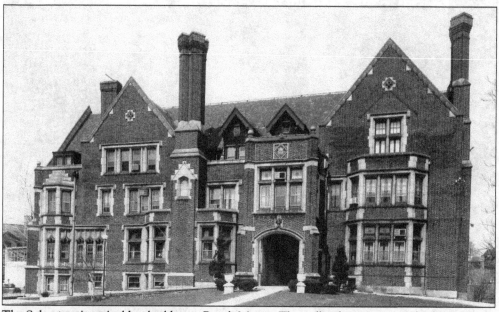

The Salvation Army's oldest building is Booth Manor. The redbrick mansion was built in 1914 for shoe magnate Joseph Tilt and designed by the legendary firm of Holabird and Roche. The Salvation Army bought it in 1920, naming it Booth Manor in honor of the Army's founder, William Booth, a Methodist who ministered to London slum-dwellers. (Courtesy of the Salvation Army.)

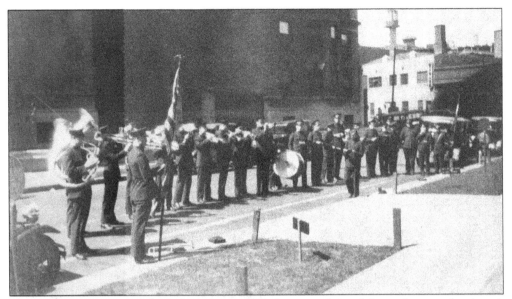

The Salvation Army strikes up the band in 1930. It was traditional for students at the Army's colleges to march around the neighborhood playing their instruments. (Courtesy of the Salvation Army.)

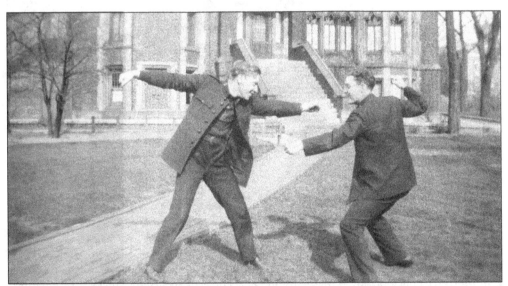

Salvation Army cadets train to become officers, and officers become generals, but despite all the titles, the young men sometimes goof around. This 1930 face-off outside Booth Manor at Broadway and Addison Street is labeled a "sham battle" in a cadet's scrapbook. (Courtesy of the Salvation Army.)

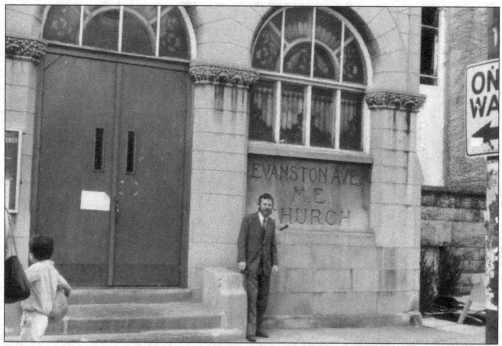

Broadway United Methodist Church has been located at Broadway and Buckingham Place since 1902, but it was originally called Evanston Avenue Methodist Episcopal Church, after the street's first name. The congregation itself dates to 1891. (Courtesy of Melferd Bose.)

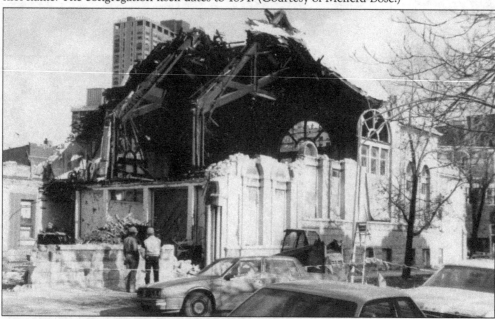

A fire burned through Broadway Methodist in 1983. The blaze spelled the end for a distinguished edifice that was designed by the architect of the famed Brewster Apartments. The congregation of four dozen worshipped elsewhere for seven years, persevered, and raised enough money to build a new church. It is the strikingly modern brick structure one sees today at Broadway and Buckingham Place. (Courtesy of Melferd Bose.)

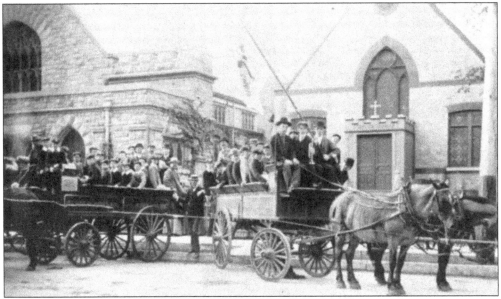

St. Peter's Episcopal Church, 621 West Belmont Avenue, was built in 1895. The little Gothic church, which once boasted 3,500 members, was said to have been the most populous Episcopal parish west of the Allegheny Mountains. Here, the boys choir embarks on a trip to Lake Geneva on July 4, 1899. The congregation, now much smaller, decided to move as its building deteriorated in 2016. (Courtesy of Sulzer Regional Library, Chicago Public Library, RLVCC 1.92.)

The Second Unitarian Universalist Church has stood at 656 West Barry Avenue for more than a century. In 1902, the church moved from Dearborn and Walton Streets, where it occupied what became the Scottish Rite Cathedral. Declining in membership, the church built this smaller structure and revived. The church suffered a second membership plunge in the 1970s, only to revive again. (Photograph by author.)

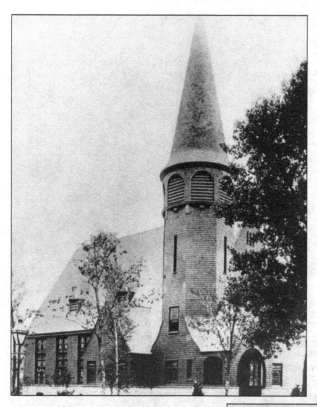

Lake View Presbyterian Church claims to be the neighborhood's oldest institution operating in the same building. The church at Broadway and Addison Street certainly has one of the most architecturally distinguished buildings. Famed Chicago architect John Wellborn Root designed the unusual cedar-shingled church, which was finished in 1888. (Courtesy of Lake View Presbyterian Church.)

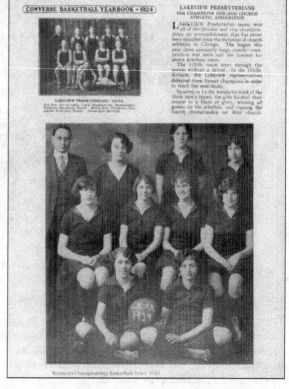

The Lake View Presbyterian women's basketball team won its fourth championship in the Chicago Church Athletic Association in 1924. The church had plenty of members to form sports teams. Membership stood at 500-plus by the 1920s, a reflection of the era when Protestants populated East Lake View and attended churches like Lake View Presbyterian and St. Peter's Episcopal. (Courtesy of Lake View Presbyterian Church.)

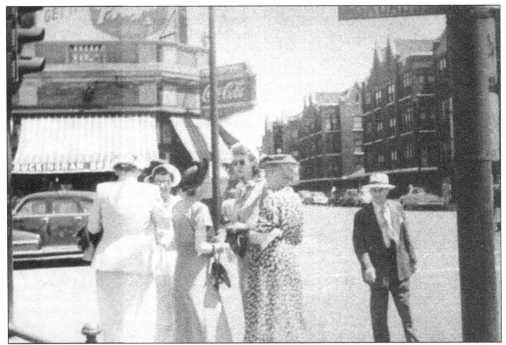

Lavina Moore (with dark glasses) and other ladies gather outside Lake View Presbyterian's front door in the 1940s. Behind them is the partly visible sign for Sara Kaplan Pharmacy, 3601 North Broadway. (Courtesy of Lake View Presbyterian Church.)

By the 1960s, Lake View Presbyterian had wrapped its walls in asbestos siding. The church grew dingy over time, and in 2005, the church restored its wooden shingles to their former glory. The restoration reflected a stronger church. When the Rev. Joy Douglas Strome started in 1996, she had 47 members. Her flock has more than quintupled. (Courtesy of Lake View Presbyterian Church.)

Swedish immigrants laid the cornerstone for Trinity Lutheran Church in 1887 at Seminary and Barry Avenues. Swedish services were held almost exclusively until 1926, when English ones were added. The church was sold in the 1970s to a Spanish-speaking congregation. (Courtesy of Resurrection Lutheran.)

Nine years after Trinity Lutheran was built, and two blocks north of it, Messiah Lutheran Church started at Seminary Avenue and School Street as another Swedish American church. Messiah, however, was English-speaking, the only one in its synod. (Courtesy of Resurrection Lutheran.)

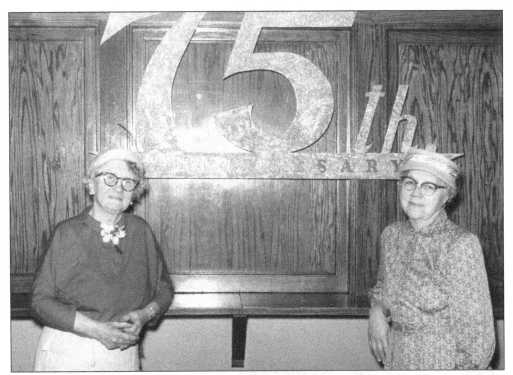

Anna Jacobson and Hilma Olson rest at Trinity Lutheran's 75th anniversary celebration. Trinity converted to English for its main worship service around 1940. The church's traditional Swedish Christmas service, Julotta, continued to broadcast on WMAQ radio into the 1970s. (Courtesy of Resurrection Lutheran.)

Musicians provide entertainment, presumably at Trinity Lutheran's 75th anniversary celebration. (Courtesy of Resurrection Lutheran.)

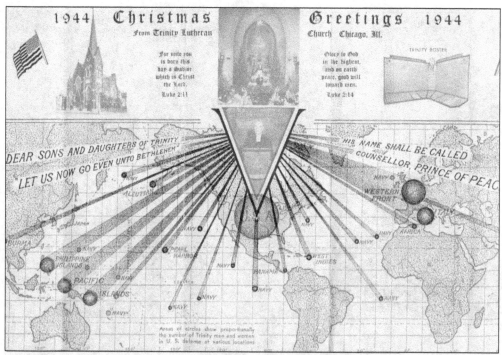

"1944 Christmas Greetings" from Trinity Lutheran. Some 340 men and women from Trinity served in the armed forces during World War II. The circles show proportionally how many members are in each location. (Courtesy of Resurrection Lutheran.)

Trinity Lutheran (pictured) merged with Messiah Lutheran in 1970, creating Resurrection Lutheran, which makes its home today in the former Messiah building. Before the merger, the Rev. Ronald "Flying Nun" Johnson would hold an 8:30 a.m. service at Messiah, run two blocks south for Trinity's 9:30 a.m. service, then run back to Messiah for its 10:45 a.m. service. (Courtesy of Resurrection Lutheran.)

Lake View Lutheran, once at Roscoe Street and Osgood Street (now Kenmore Avenue), may be the neighborhood congregation with the longest history. It dates to 1848, when it began as the Scandinavian Evangelical Lutheran Church near the Loop. The church had a Norwegian affiliation, but its help for immigrants won the gratitude of singer Jenny Lind, the "Swedish Nightingale," who donated a silver altar set. The congregation today worships in the little modern church at 835 West Addison Street. (Courtesy of Lake View Lutheran.)

This undated photograph apparently shows a Lake View Lutheran pastor at a baby shower for his wife. Over the years, this little church has done big things. According to member Sandy Moore, it started a Spanish service when Puerto Ricans moved into the neighborhood, hosted a congregation of Christians from south India, and for many years, housed the Lakeview Shelter for the homeless. (Courtesy of Lake View Lutheran.)

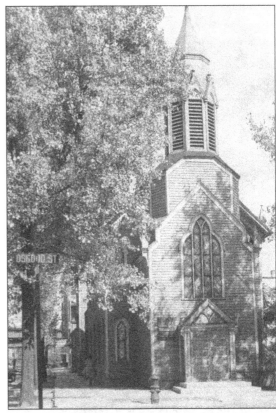

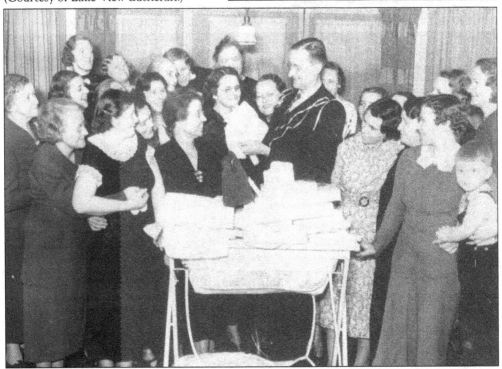

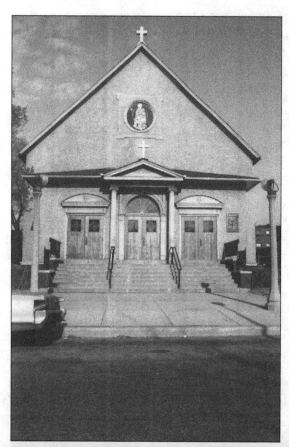

St. Sebastian Roman Catholic Church was founded in 1887 and served Lake View Catholics until 1990. The church, which stood at 820 West Wellington Avenue, held Masses for gay Catholics as early as 1973. The church lives on in the St. Sebastian Players, its theater group, which now stages shows at St. Bonaventure, 1641 West Diversey Parkway. (Courtesy of Illinois Historic Preservation Agency.)

Linda Masini holds her son Matthew for St. Sebastian's Pastor Bill Simon to christen on Easter in 1979. Linda and Jim Masini moved to the 800 block of West Wolfram Street in 1975. As a young, liberal-minded Catholic, Jim fell in love with St. Sebastian's warm community. (Courtesy of Jim Masini.)

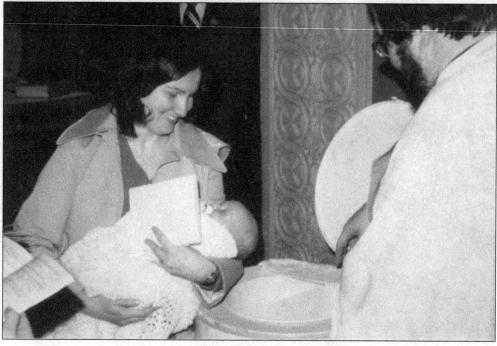

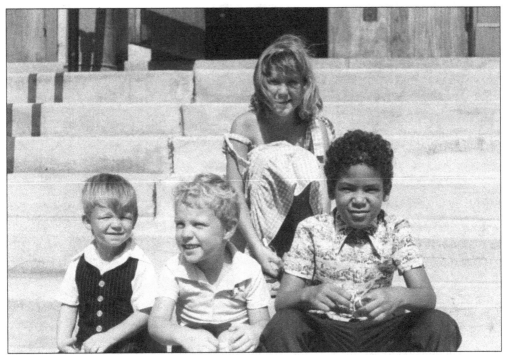

From left to right, Christopher Held; Matthew Masini, age six; Melissa Masini, age nine; and Damien Johnson, age nine, take a break on the steps of St. Sebastian in 1985. St. Sebastian was unusual in its ethnic mix. It had Puerto Rican, South American, Asian, and Polish parishioners. In 1989, St. Sebastian held three English Masses and one in Spanish. (Courtesy of Jim Masini.)

St. Sebastian's Damaged by Fire

By George S. Buse

There was extensive damage to St. Sebastian's Catholic Church's sanctuary building Friday evening as fire swept from its basement to its ceiling, leaving a gaping hole in the roof. The flames had also leaped through the circular front window, leaving a trail of soot extending upward to the cross atop the church.

The smoke had hardly cleared, however, when more than 100 of the church's parishioners, among them people representing the 18 years the church has been home to Chicago gay and lesbian Roman Catholics, filed solemnly into what remained of their building, salvaged what property they could, and vowed that their church's life will go on.

Among the most prized possessions of the parish, which they rescued intact, is the century-old Italian oil painting of the church's patron, St. Sebastian, a Fifth Century martyred saint of the Catholic Church.

Although Chicago Fire Department investigators have not yet determined the exact cause of the blaze, it is believed it may have started because of faulty electric wiring in a storage area in the basement.

Scott LaGreca, Fire Department media affairs officer, reported that until the pool of water that collected in the basement can be pumped out, investigators could not examine the area where the fire may have started.

The pumping operation continued all day Monday, and fire officials did report heavy damage in the basement, one of the walls and part of the roof. They reported also that structurally the building appears to be sound.

Insurance adjusters have not completed their assessment of the damage, but Montalbano estimated the loss will be at least a half-million dollars. Apart from the structural damage, he said, the greatest loss was to the building's stained glass windows, not only because of the cost of replacement, but because

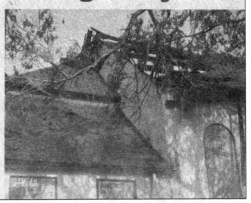

A fire in 1989 devastated the wood structure of St. Sebastian, which was already suffering from a dwindling membership. The Archdiocese of Chicago closed St. Sebastian and sold the land to Illinois Masonic Medical Center. Some members moved to St. Bonaventure, but parishioner Jim Masini said they never recaptured what they lost. (Courtesy of Jim Masini.)

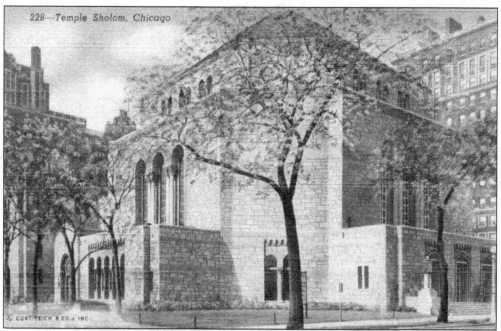

Temple Sholom stands out, physically and historically, among the synagogues in Chicago. The current building, the Byzantine structure seen in this postcard, looms large at 3480 North Lake Shore Drive. The Reform congregation dates to 1867, when Chicago was young. (Courtesy of Garry Albrecht.)

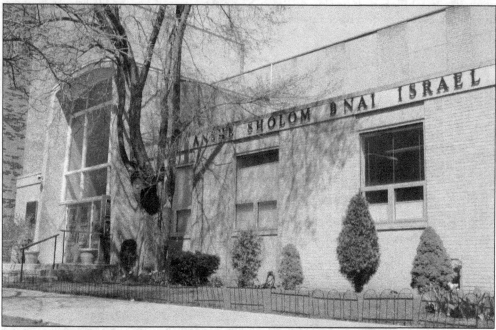

Anshe Sholom B'nai Israel synagogue is tucked away on Melrose Street just east of Broadway. It has been at that address since 1940 and is one of the only Orthodox synagogues south of Bryn Mawr Avenue. Mayor Rahm Emanuel is a member (although not seen much), as was famed US judge Abe Marovitz. (Photograph by author.)

Four

SWEDISH EAST LAKE VIEW

The father of Swedish Lake View was a man named Johan Enander. A scholar, he settled at 3256 North Wilton Avenue in 1883, and Swedish immigrants clustered around him. Swedish immigrants poured into the United States at the end of the 19th century, driven by overpopulation and under-industrialization. Chicago boasted the biggest Swedish population in the United States, and East Lake View was one of the hubs for settlement.

Swedes earned a reputation as excelling at skilled trades. They also founded many businesses, a few of which have survived until recent years. Torstenson Glass dates to the 19th century and is one of East Lake View's oldest businesses now that Anderson Movers, another Swedish firm, has departed. Of course, in the 1940s on Belmont Avenue, there was the Swedish Diner, now known by the name of the woman who became its owner, Ann Sather.

Lake View's Swedish American population plummeted after World War II. In 1930, more than 13,000 Lake Viewers claimed Swedish heritage. By 1960, the number had fallen under 4,000. In 1969, Trinity Lutheran stopped offering Swedish services. Clubs, like the Swedish Engineers society, watched their memberships shrivel. The society's housekeeper lamented the decline to a *Tribune* columnist in 1971. "There have been a lot of happy times here," she said. "If there were only more people to reminisce with."

An advertisement in a 1949 church publication reveals the original name for Ann Sather Restaurant—the Swedish Diner. Ann Sather bought the diner in 1945 and named it after herself. (Courtesy of Holy Trinity Lutheran Church.)

This was Ann Sather Restaurant's second location, 925 West Belmont Avenue. (Courtesy of Ann Sather Restaurant.)

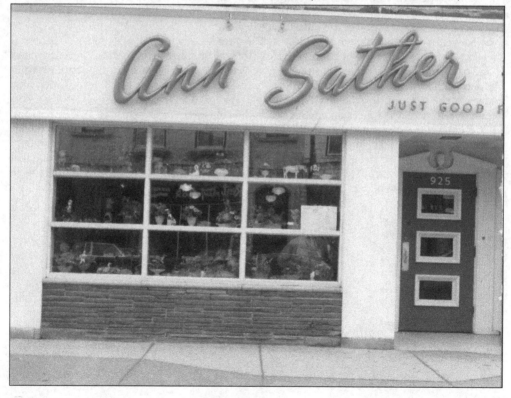

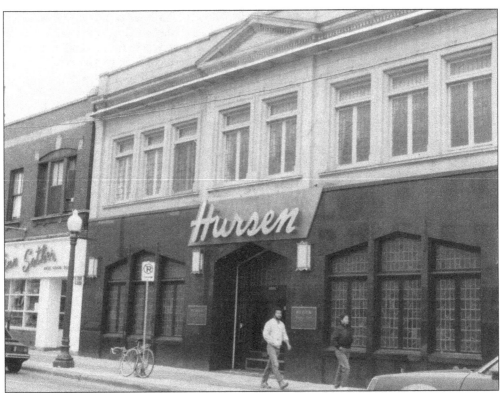

Ann Sather sold her restaurant in 1981 to Tom Tunney, and it moved into what had been Hursen funeral home, 929 West Belmont Avenue. The restaurant is now at its fourth location on the block, 909 West Belmont, which serves as home base to what has become a three-restaurant chain. (Courtesy of Ann Sather Restaurant.)

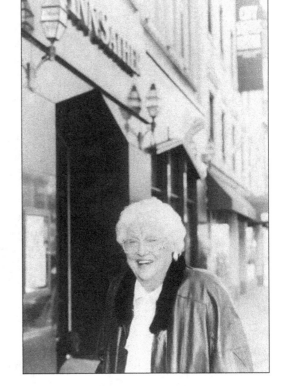

Ann Sather, who died in the 1990s, smiles outside the restaurant. She grew up in a Scandinavian farm town in North Dakota, according to the restaurant, and came to Chicago to work for her uncle, a meat purveyor. She spent $4,000 to buy the restaurant to which she left her name. (Courtesy of Ann Sather Restaurant.)

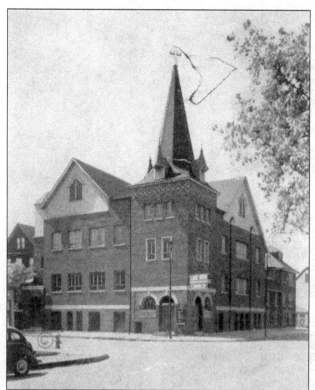

The once-popular Lake View Mission Covenant Church stood at School Street and Kenmore Avenue for decades. The church was part of what is now known as the Evangelical Covenant Church, a denomination that Swedish immigrants founded in Chicago (along with Swedish Covenant Hospital). In Lake View, the congregation had more than 1,000 students in its Sunday school at one point, but eventually closed. The building is now a condominium. (Courtesy of Covenant Archives and Historical Library, North Park University, Chicago.)

Founded in 1889, Torstenson Glass is one of Lake View's oldest companies—and one of its few remaining manufacturers. Torstenson makes and distributes glass and mirrors at 3233 North Sheffield Avenue, in the heart of the old Swedish neighborhood. (Photograph by author.)

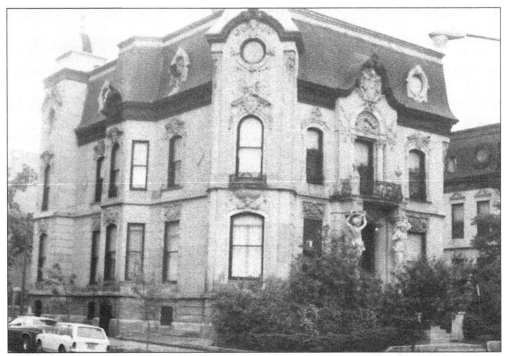

This baroque giant at 503 West Wrightwood Avenue served as the headquarters of the Swedish Engineers society for many decades. The group, founded in 1908, aimed to promote knowledge and advancement among technical-minded men of Swedish origin. (Courtesy of Library of Congress.)

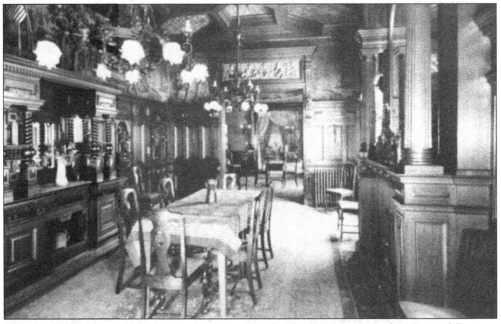

The Swedish Engineers' clubhouse was so spectacular that it was put in the National Register of Historic Places. A developer put the house up for sale in 2010 after restoring it. (Courtesy of Library of Congress.)

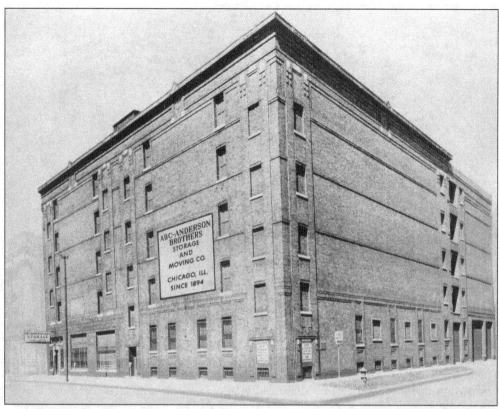

Anderson Brothers once ranked as one of Lake View's oldest businesses. The moving company was founded in 1894 by two Swedes and was located for many years at 3141 North Sheffield Avenue, seen in the undated photograph above. The business is now owned by the Miller family, which bought it from an Anderson relative. In 2013, Anderson Brothers sold its building for residential development, pictured below, and moved to the South Side. The warehouse's new residents likely will not be told about one historical detail. In 1945, a trunk stored at Anderson yielded clues in the case against Alfred "Bluebeard" Cline. The notorious man was suspected of killing eight wives, including a Lake View woman. (Above, courtesy of Judy Miller; below, photograph by author.)

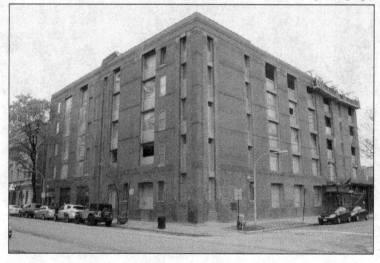

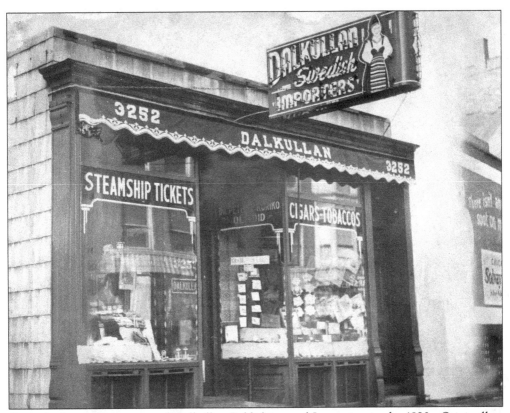

Capt. Anders Lofstrom started Dalkullan Publishing and Importing in the 1890s. Originally a newsstand, the business was expanded by Dalkullan into a travel agency, imported gifts store, and seller of pirated books and songs from Sweden. Dalkullan did business for decades at 3252 North Clark Street before closing in 1972. Pictured below, Anders Lofstrom, second from left, stands with his workers at the Dalkullan shop. According to the Swedish-American Archives of Greater Chicago, the name Dalkullan likely is slang for a girl from the Swedish province of Dalarna, and Lofstrom indeed sold cigars hand-rolled by Dalarna women. (Both, courtesy of the Swedish American Museum, Chicago, Illinois.)

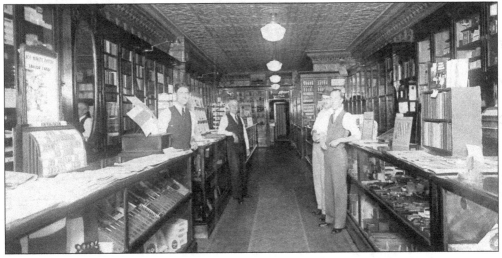

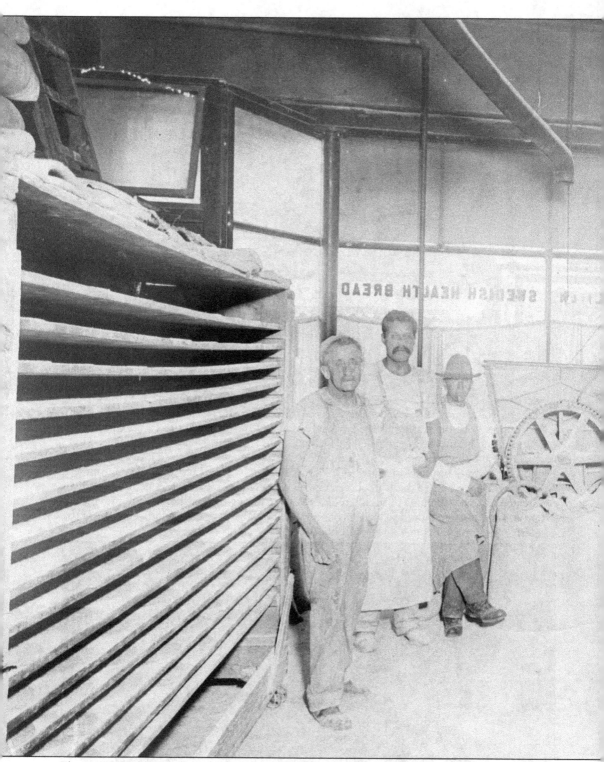

Ekstrom & Walden's bakery operated at 3709 North Clark Street. This simple, posed photograph reveals a lot. In the back, the sign in the window hints at what kind of bakery it was, reading,

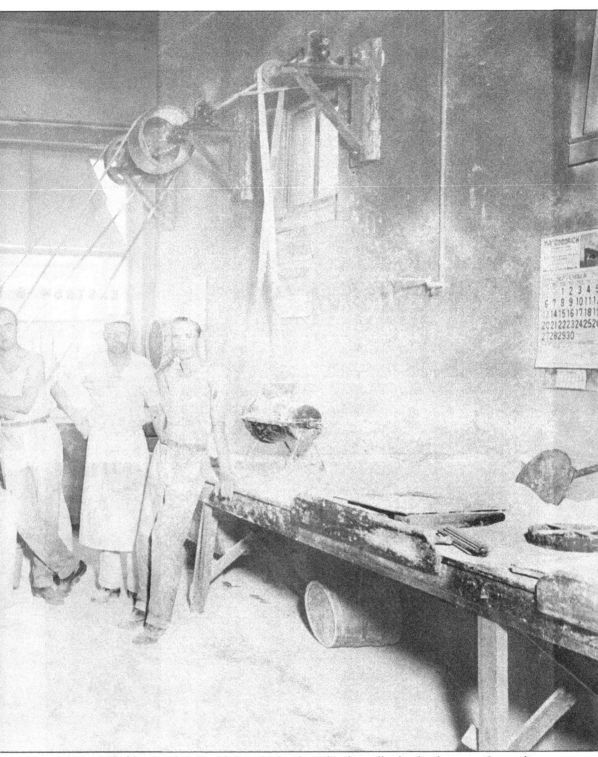

"Ekstrom & Walden Swedish Health Bread." On the right, the wall calendar shows it is September 1914. (Courtesy of the Chicago Public Library, Sulzer Regional Library, RLVCC 1.23.)

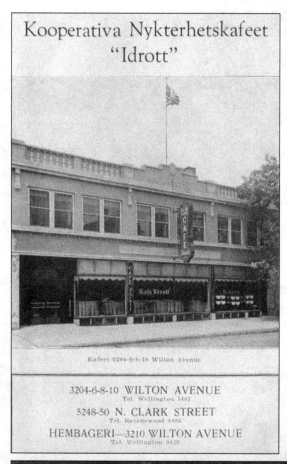

Kooperativa Nykterhetskafeet "Idrott"

Kafeet 3204-6-8-10 Wilton Avenue

3204-6-8-10 WILTON AVENUE
Tel. Wellington 5461

5248-50 N. CLARK STREET
Tel. Ravenswood 8056

HEMBAGERI—3210 WILTON AVENUE
Tel. Wellington 9420

Swedes in Lake View started an immigrant cooperative that promoted fitness, temperance, and self-help. The group's clubhouse was Café Idrott, seen in a 1930 annual report. Idrott, at 3204–3210 North Wilton Avenue, was more than a café. It offered a library, game room, overnight rooms, and a mailing address for men who had not found a home or were running from Sweden's draft. (Courtesy of the Swedish American Museum, Chicago, Illinois.)

Café Idrott's manager Ericka Hedman lines up with her staff, from left to right, Lina Bjork, Ellen Anderson, and Augusta Wilson (the latter apparently an American). This photograph was taken in the café's first year, 1913. The Café Idrott building was torn down in 2006. (Courtesy of the Swedish American Museum, Chicago, Illinois.)

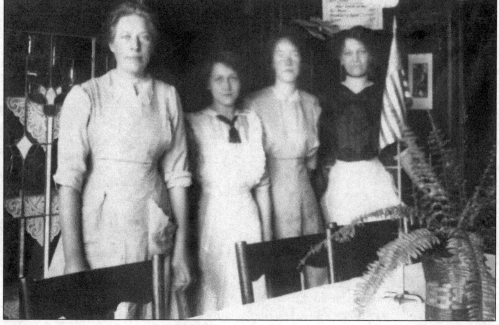

Five

JAPANESE AMERICAN EAST LAKE VIEW

Many groups came to East Lake View. Few took such a difficult and twisting path as the Japanese Americans.

In 1941, the bulk of America's Japanese population lived on the West Coast. Perhaps a few hundred lived in Chicago. All that changed after Japan's attack on Pearl Harbor. Japanese Americans, citizens or not, fell under suspicion. Authorities rounded them up on the West Coast and sent them to camps. The government soon decided internees should resettle, but where?

A merchant at the Gila, Arizona, internment camp named Jun Toguri got permission to tour the Midwest. He came back with advice for his fellow internees that was reported by the local newspaper: "Toguri doesn't recommend St. Louis as a good resettlement area, because of discrimination toward minorities, but he believes there is space for many more Japanese in Chicago." By the end of the war, 20,000 Japanese Americans had moved to Chicago. Many found their way to Lake View.

Jun Toguri took his own advice and opened a shop in Chicago, first near Clark and Division Streets, then near Clark and Belmont Avenue. His American-born daughter, meanwhile, had undergone an ordeal more difficult than his. Iva Toguri was visiting Japan when war broke out. During the war, she was one of the English-speaking women—collectively called "Tokyo Rose"—who made radio broadcasts to US troops. Her propaganda tended toward the silly: "Hello there, enemies! How's tricks?" After Japan's defeat, Gen. Douglas MacArthur's occupying forces had no interest in prosecuting her, but a press campaign led to charges and six years in prison. Released in 1956, Iva Toguri D'Aquino, now married, headed to Chicago to work at her father's shop. For years, she minded the store at J. Toguri Mercantile Co. She spoke little of her case, but another press campaign—this time by the *Chicago Tribune*—led to a presidential pardon.

The woman called Tokyo Rose died in 2006. Shortly before her death, a World War II veterans group gave her a medal at a ceremony at Yoshi's Café, the Lake View restaurant she helped start. "She was tearful and overcome with emotion," a veterans group official recalled. "It was part of a long process of vindication."

The Japanese Americans of Lake View proved entrepreneurial. They started shops like Toguri's, restaurants like Matsuya, and institutions like the Japanese Culture Center. Like the Swedes they replaced, the Japanese proved too successful to stick around, and many moved to the suburbs. The Nisei Lounge remains, but with few nisei (American-born and -educated sons and daughters of immigrant Japanese parents) inside. What remains at the Nisei is a wall of historical photographs and news clippings paying tribute to the people who made it what it was.

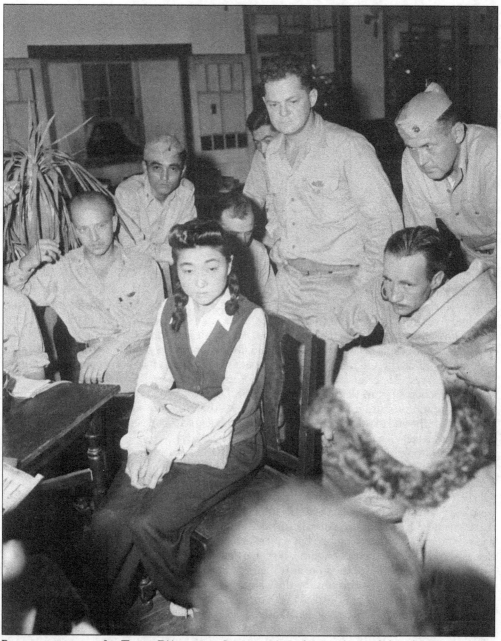

Reporters interview Iva Toguri D'Aquino in Japan in 1945 after word spread that she was the voice of Tokyo Rose. "I didn't think I was doing anything disloyal to America," she told journalists. (Courtesy of National Archives and Record Administration.)

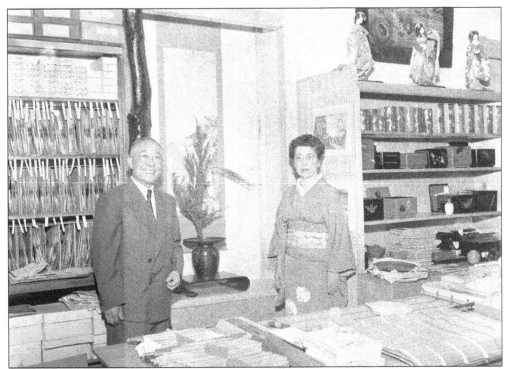

Iva Toguri D'Aquino's father, Jun Toguri, and an unidentified woman welcome visitors to his Chicago import shop in 1951. At the time, Iva Toguri D'Aquino was in prison. Her insistence on staying loyal to the United States, even after her jailing, made her father proud. She recalled him telling her, "You never changed your stripes." (Courtesy of Mary and James Numata Photograph Collection, Japanese American Service Committee.)

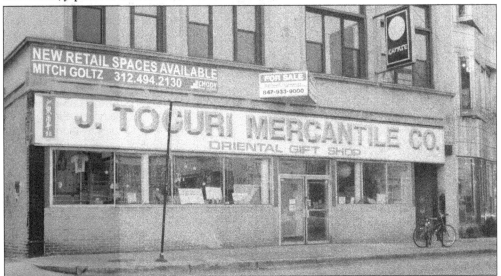

The Toguri family's shop at 851 West Belmont Avenue thrived for decades in Lake View before closing in 2013. Iva Toguri D'Aquino rarely talked about her imprisonment, and many did not know the identity of the quiet woman working at the store. In a rare interview before she died, Iva told the *Chicago Tribune*, "What good does it do to be bitter?" (Photograph by author.)

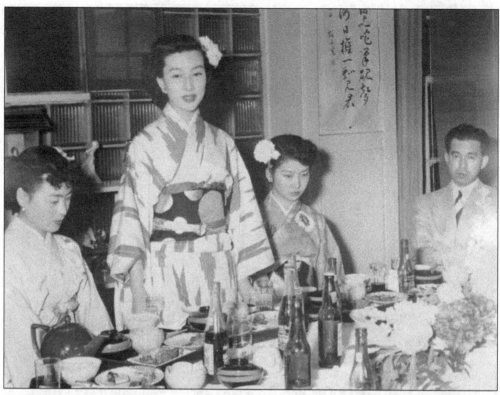

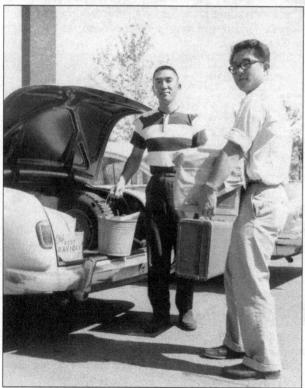

In 1951, Miss Nippon, Fujiko Yamamoto, stopped in Chicago. The beauty queen visited the Toguri gift shop. (Courtesy of Mary and James Numata Photograph Collection, Japanese American Service Committee.)

The Japanese American Service Committee in the 1960s was located in the heart of its community at 3257 North Sheffield Avenue. In 1969, young men like the ones here helped the committee move to 4427 North Clark Street, where it is today. The committee, which originally helped the Japanese settle in Chicago, has embarked on new endeavors. One recent project was setting up the archive that preserves photographs such as this one. (Courtesy of Record Group 10: Audio-Visual Resources, Japanese American Service Committee.)

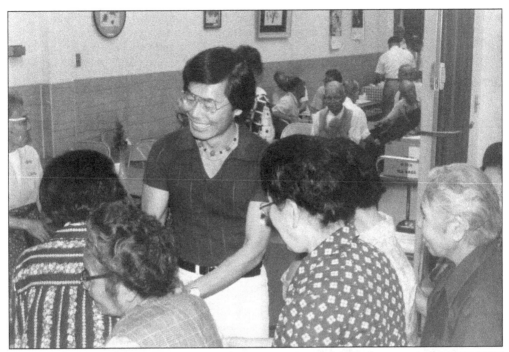

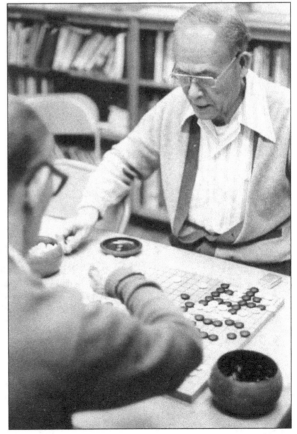

George Takei, one of the rare Japanese Americans in Hollywood, greets fans in 1978 at the Japanese American Service Committee. He was famous by then for playing Mr. Sulu on the television show *Star Trek*. (Courtesy of Record Group 10: Audio-Visual Resources, Japanese American Service Committee.)

Men play the ancient Japanese game of Go in 1975. The goal is to surround more space than one's foe. (Courtesy of Record Group 10: Audio-Visual Resources, Japanese American Service Committee.)

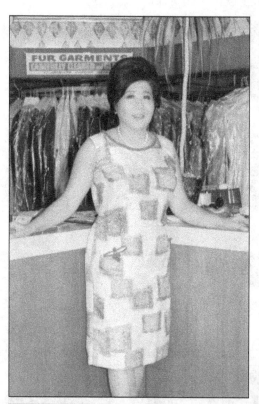

Mona Sasaki founded a business that became a mainstay on Broadway: Barry-Regent Cleaners. As a Japanese American on the West Coast, Sasaki was sent to an internment camp during World War II. Like many, she wound up in Chicago, and in 1950, she opened the cleaners in Lake View. (Courtesy of Barry-Regent Cleaners.)

Barry-Regent Cleaners is seen not long after its move to 3000 North Broadway in 1964. The business started when Mona Sasaki opened Barry Cleaners at Barry Avenue and Broadway in 1950. Fourteen years later, Sasaki bought Regent Cleaners, combined the names, and moved into Regent's space, pictured below. For a while, the business had signs with different names. (Courtesy of Barry-Regent Cleaners.)

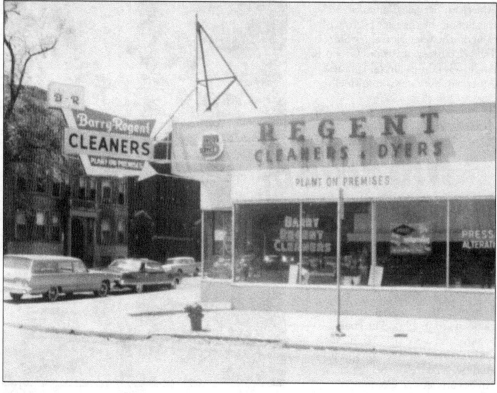

BARRY CLEANERS

announces the acquisition of the Dry Cleaning plant, Modern Finishing Facilities and Cold Storage Vault of the REGENT Cleaners & Dyers.

As of June 1st, 1964 the combined Operations of

BARRY-REGENT CLEANERS

will now be located at

3000 N. BROADWAY · CHICAGO 60657

Thank you for your Patronage and we wish to serve you even better in the future.

Phone:
WE 5-0053 · DI 8-5510

BARRY-REGENT CLEANERS
3000 N. Broadway

Barry Cleaners announces the combined Barry-Regent Cleaners. Keeping Barry in the name even as the business moved down Broadway to the corner of Wellington Avenue created the everlasting potential for confusion. (Courtesy of Barry-Regent Cleaners.)

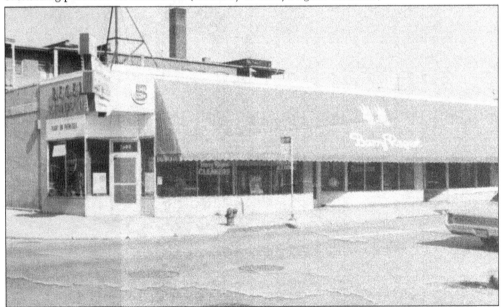

Barry-Regent has survived from 1950 until now by "doing things the right way," manager Richard Atack says. He represents the third generation involved in the cleaners. Atack is the son-in-law of John Sasaki, the son of founder Mona Sasaki. In the early days of the business, Atack says, the family worked 70 hours a week to make a success of it. (Courtesy of Barry-Regent Cleaners.)

The Nisei Lounge claims the title of oldest continuously operating bar in Wrigleyville, having been at 3439 North Sheffield Avenue since 1951. As the name indicates, it was owned and patronized by Japanese Americans for decades. A back door connected it to Hamburger King (now Rice 'N Bread), another Japanese American hangout. Nisei Lounge's ownership and clientele changed years ago, but it still serves Sapporo beer. (Photograph by author.)

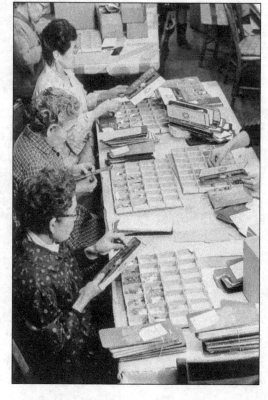

Women busy themselves in 1969 at the Japanese American Service Committee's Issei Work Center. The term *issei* refers to a Japanese immigrant to the United States. (Courtesy of Record Group 10: Audio-Visual Resources, Japanese American Service Committee.)

Six

ALTERNATIVE
EAST LAKE VIEW

It was the 1970s. Leftover hippies, young singles, and artists needed a place to live in Chicago. Old Town was yesterday's news, and Lincoln Park was filling up. The next move had to be to East Lake View. It was so ripe to be the new Old Town that someone went ahead and called it New Town.

The freedoms spawned in the sixties aged into a wild scene in East Lake View. By day, it was mod shops, head shops, and antique shops. Come night, there were folk bars, singles bars, gay bars, American Indian bars, hillbilly bars, and something called the Fat Black Pussycat. Outside the bars, hookers roamed. One told a reporter: "As long as I can make this kind of bread, I ain't gonna quit."

Something had to give, and it did. The AIDS crisis curbed sexual appetites. Drug paraphernalia laws made it harder to satisfy other kinds of appetites. By the 1980s, Mark Thomas, owner of the Alley on Broadway, decided he needed a new location. He spotted the punkers outside Dunkin' Donuts on Belmont Avenue and realized he was looking at future customers, so he moved the Alley nearby. The alternative scene was relocating.

The Lake View Triangle, as Medusa's manager Greg Blue Pittsley called it, was born. If Belmont and Racine Avenues were the legs, and Clark Street the hypotenuse, the triangle's apex was at Smart Bar and Cabaret Metro. You could shop for clothes at the Alley, wait for Medusa's to open at the "Punkin'" Donuts, and finally, dance at Medusa's come 11:00 p.m. If you were old enough, you could wind up at Smart Bar or Berlin. If not, you could go to Muskie's hamburger joint and wait for your parents to pick you up.

The triangle took its first hit in 1992. Medusa's closed, forced out by a developer who wanted to turn the building into pricey residences. More professionals moved to East Lake View, and the counterculture jumped to Wicker Park. East Lake View's alternative past wound up serving as a prelude to its affluent present.

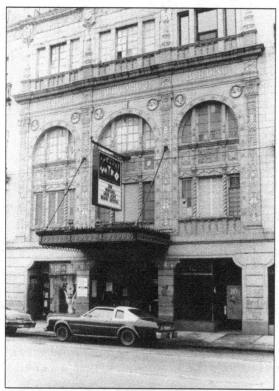

Metro, seen in 1990, is one of Chicago's great concert halls. At first called Cabaret Metro, the club began in 1982 in an old Swedish center at 3730 North Clark Street called the North Side Auditorium Building. Metro helped launch Smashing Pumpkins, although on this day in 1990, the marquee reveals Nirvana is playing. (Courtesy of Chicago Public Library, Sulzer Regional Library, RWK 17.16.)

Dave "Medusa" Shelton spotted a For Rent sign on this Swedish social hall at 3257 North Sheffield Avenue in the early 1980s. He opened an all-ages nightclub there, birthing the one and only Medusa's. "This was Chicago's own version of New York's Studio 54, only younger, hipper, more creative and less pretentious," Medusa's own history claims. (Courtesy of Record Group 10: Audio-Visual Resources, Japanese American Service Committee.)

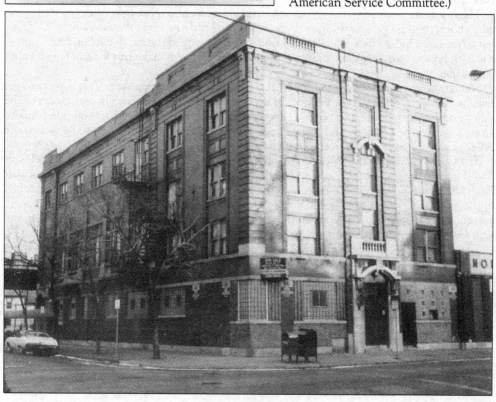

Medusa's and its crowd of high school outcasts, drag queens, and skinheads drew talent like the Red Hot Chili Peppers, in the ad at right, not to mention Smashing Pumpkins and an MTV crew. There are too many Medusa's stories to count, from legendary DJ Frankie Knuckles spinning records to Shannon belting out her disco anthem "Let the Music Play" at 6:30 a.m. on a Sunday in 1984. Some say it was 9:00 a.m. (Courtesy of Joe Michelli.)

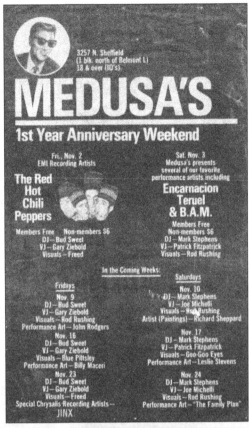

3257 N. Sheffield
(1 blk. north of Belmont L)
18 & over (ID's)

MEDUSA'S

1st Year Anniversary Weekend

Fri., Nov. 2
EMI Recording Artists

The Red Hot Chili Peppers

Members Free Non-members $6
DJ—Bud Sweet
VJ—Gary Ziebold
Visuals—Freed

Sat. Nov. 3
Medusa's presents several of our favorite performance artists including

Encarnacion Teruel & B.A.M.

Members Free
Non-members $6
DJ—Mark Stephens
VJ—Patrick Fitzpatrick
Visuals—Rod Rushing

In the Coming Weeks:

Fridays	Saturdays
Nov. 9	Nov. 10
DJ—Bud Sweet	DJ—Mark Stephens
VJ—Gary Ziebold	VJ—Joe Michelli
Visuals—Rod Rushing	Visuals—Rod Rushing
Performance Art—John Rodgers	Artist (Paintings)—Richard Sheppard
Nov. 16	Nov. 17
DJ—Bud Sweet	DJ—Mark Stephens
VJ—Gary Ziebold	VJ—Patrick Fitzpatrick
Visuals—Blue Pittsley	Visuals—Goo-Goo Eyes
Performance Art—Billy Maceri	Performance Art—Leslie Stevens
Nov. 23	Nov. 24
DJ—Bud Sweet	DJ—Mark Stephens
VJ—Gary Ziebold	VJ—Joe Michelli
Visuals—Freed	Visuals—Rod Rushing
Special Chrysalis Recording Artists— JINX	Performance Art—"The Family Plan"

Jennifer Marszalek and Steele Rohman hang out in Medusa's DJ booth in the early 1990s. Marszalek started going to Medusa's as a teen and later promoted the club. She said many Chicagoans recall Medusa's with such fondness because it was the first club they frequented, saying, "You were doing something grownup that all your other friends weren't doing." (Courtesy of Jennifer Marszalek.)

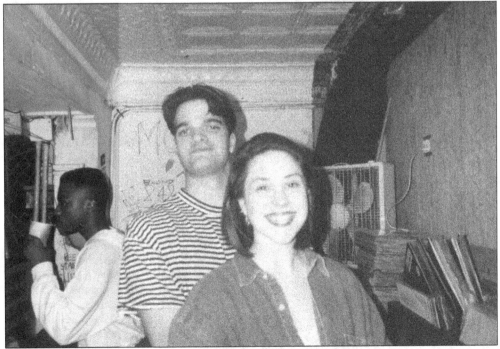

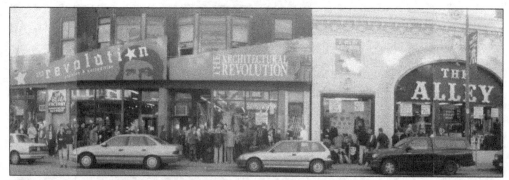

This montage shows the Alley, 3228 North Clark Street, in its glory days. The store for punkers, rockers, and goths was a mainstay of Lake View's alternative scene. Owner Mark Thomas also opened Architectural Revolution, Blue Havana cigar store, and Taboo Tabou adult toy emporium around the Alley. All except Taboo Tabou were closed by 2016. (Courtesy of Mark Thomas.)

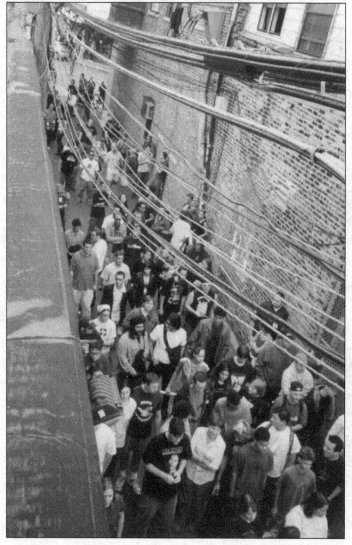

In 1986, the Alley opened off the alley that ran west of, and parallel to, the 3200 block of North Clark Street. The first Alley store actually was a head shop at Woodfield Mall that opened in 1976. More locations followed, including one at Broadway and Surf Street, before the Alley moved to a real alley, this one behind Clark Street. Eventually, the Alley moved to Clark Street itself. (Courtesy of Mark Thomas.)

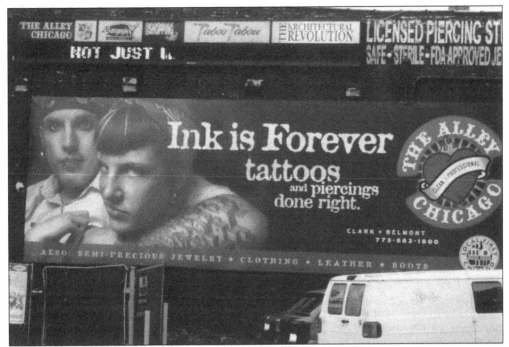

The Alley not only sold clothing and accessories, but all sorts of body decorations. (Courtesy of Mark Thomas.)

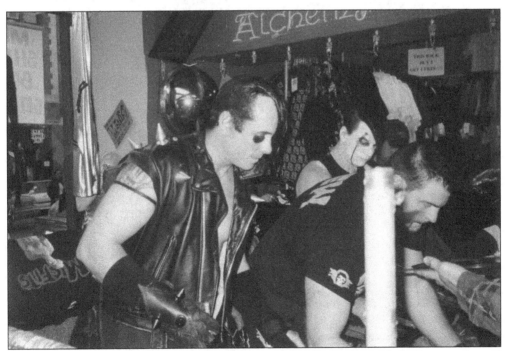

The Misfits, who pioneered "horror punk," appear at the Alley in 2000. Mark Thomas, who still operates the Alley as a Web business, dislikes what he sees as too many chain stores in Lake View. He ran for alderman in 2015 but lost decisively to Tom Tunney. (Courtesy of Mark Thomas.)

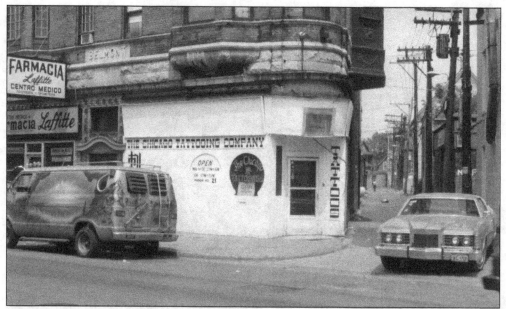

Chicago Tattooing boasts that it is Chicago's oldest tattoo shop. It started in this storefront at 900 West Belmont Avenue (now Egor's Dungeon). This photograph is from the 1970s, but the business was founded in the 1960s by Cliff Raven, a nationally famous—and nationally imitated—tattoo artist. At one time, he was the only tattoo artist in Chicago's Yellow Pages, thanks to the city's legal restrictions. (Courtesy of Chicago Tattooing.)

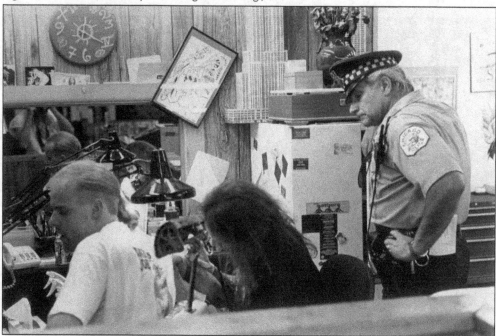

Chicago Tattooing's Curtis Love (center) works on a customer under the eye of Ofc. Duane Leonard, the neighborhood beat cop. The shop today is owned by Dale Grande, a onetime glazier who talked his way into a job at the tattoo shop by offering to mop floors and run errands. (Courtesy of Chicago Tattooing.)

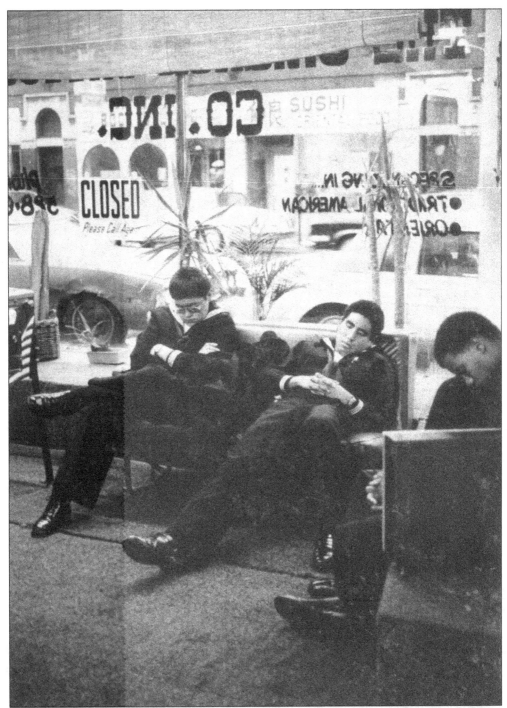

Recruits from the Great Lakes Naval Training Center snooze while they wait to get inked at Chicago Tattooing in 1982. In Chicago Tattooing's early days, when city laws left it few rivals, the shop drew crowds. "We'd have people lined up outside, like Ann Sather's," owner Dale Grande says. Note through the window the signs for restaurants across the street: Boca del Rio and a sushi place, Nakayoshi. (Courtesy of Chicago Tattooing.)

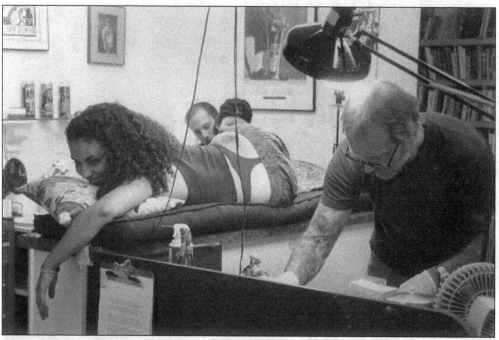

Chicago Tattooing artist Dave McNair practices his craft on a young woman in the 1990s. McNair started working at the tattoo shop in 1987. (Courtesy of Chicago Tattooing.)

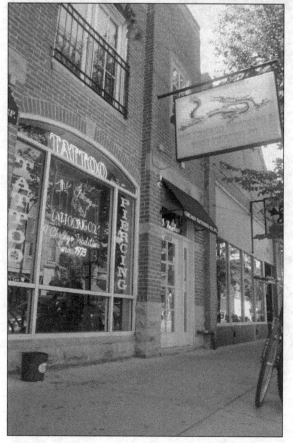

Chicago Tattooing operates today at 1017 West Belmont Avenue, a block west of its original location. When the shop moved to the site in 2005, new neighbors complained. "They've been here six months, and they tell me, I don't belong here!" Grande, the owner, says. In the end, he says, opposition was light. (Courtesy of Chicago Tattooing.)

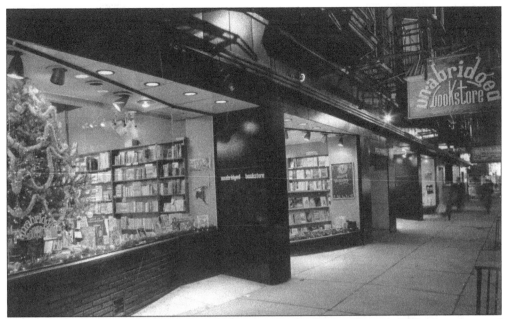

Unabridged Bookstore is one of the last independent booksellers in Chicago. Ed Devereux opened the store in 1980 at 3251 North Broadway. Devereux attributes his survival to a good location, focusing on just books (no coffee or gifts), and operating as a bookstore with a big gay section, not as an exclusively gay bookstore. This photograph shows Unabridged about 1990, when it had a hanging sign. (Courtesy of Unabridged Bookstore.)

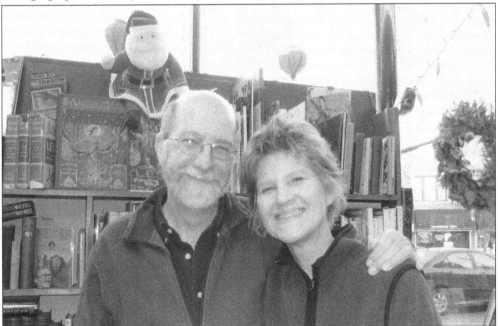

Bookworks owners Bob Roschke and his wife, Ronda Pilon, smile at Christmastime in 2011. Unlike Unabridged Bookstore, Bookworks did not survive. The used bookstore, which opened in 1984 at 3444 North Clark Street, outlasted Borders but not Amazon.com. Bookworks closed in 2016, blaming the Internet, rising rents, and the bar-ification of Wrigleyville. (Courtesy of Bookworks.)

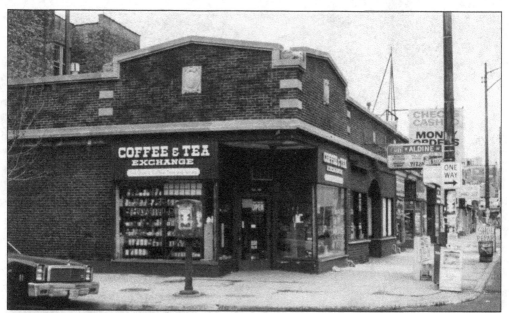

The Coffee & Tea Exchange opened in 1975 at 3300 North Broadway selling coffee beans to serious java drinkers. It started almost by accident; Steve Siefer wanted to be his own boss, and his friend Peter Longo noticed his family grocery store was selling a lot of beans. The pair decided quality coffee was a trend and went into business. Coffee & Tea Exchange thrives today across the street and boasts a roastery on the West Side. (Courtesy of Jim Persino.)

What's an alternative neighborhood without a vegetarian restaurant? Chicago Diner, 3411 North Halsted Street, started in 1983. The restaurant defied scoffers and survived into the veggie-friendly era of today. A magnifying glass reveals a secret about this 1987 photograph. The couple in the window are having a very intense encounter! (Courtesy of Chicago Public Library, Sulzer Regional Library, RWK 7.10.)

Seven

BOYSTOWN

Why is East Lake View the site of Chicago's biggest gay neighborhood? Gays have followed bohemians for decades. Sometimes, they were the same people. First, there was a gay presence in Tower Town, the artist district west of the Water Tower, in the 1930s. As hippies and alternative types moved north, gays followed.

By 1975, gay bars had clustered just south of Lake View. There was a strip on Halsted Street south of Diversey Parkway that included Carol's Coming Out Pub, the Snake Pit, and El Dorado. That year, Jim Gates made the jump to 3501 North Halsted Street, establishing the first bar on Halsted in what would be called Boystown. Many gay businesses followed, from the Unicorn Club, now Steamworks Baths, to Sidetrack.

For years, Boystown made up part of alternative East Lake View. But when hipsters moved west across the Chicago River in the 1990s, Boystown stayed put. Gays were quickly moving out of the alternative category, plus a gay-branded business often equaled a lucrative business.

Two news events in the 1990s sealed Boystown's status as the recognized LGBT neighborhood in Chicago. The pride parade crowd was estimated at 100,000 at the beginning of the decade, and the city installed rainbow pylons to mark Boystown at the end of the decade. As many ruefully have observed, the more gays are recognized, the less gay Boystown actually seems to be. Gays now can safely live across the North Side, and many do. One DNAinfo article quips: "Goodbye gayborhood, hello, strollers."

Long after this picture was taken, this building became the site of Chicago gay history. In 1975, Little Jim's Tavern opened in the corner space at Halsted and Cornelia Avenue. Little Jim's is believed to be the first gay bar on what would become Boystown's fabled Halsted strip. (Courtesy of Gerber/Hart Library and Archives.)

CITY RETAILER'S LICENSE— ALCOHOLIC LIQUOR

6501

BY AUTHORITY OF THE

CITY of CHICAGO CLASS A

PERMISSION IS HEREBY GIVEN $535.00

me. James H Gates

dress. 3501 N. Halsted St (zip 60613), CHICAGO, ILL.

ell at retail alcoholic liquors as defined by law at 1st Fl.
ddress stated, above, in said City until the FIRST DAY OF NOVEMBER, subject to the laws of State of Illinois, and the ordinances of said City in such case made and provided.

WITNESS the hand of the Mayor as the local liquor control commissioner of said City, and the Corporate Seal thereof, this 2nd day of June, 1975.

1975

NON-TRANSFERABLE
Note.—This License Expires
October 31, 1975
FIRST PERIOD

RICHARD J. DALEY
Richard J. Daley
MAYOR

ATTEST JOHN C. MARCIN
John C. Marcin
CITY CLERK

This image of Little Jim's first liquor license, while incomplete, documents the founding of the bar in 1975. (Courtesy of Gerber/Hart Library and Archives.)

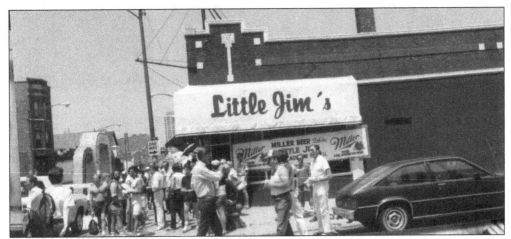

As Little Jim's aged, it grew to be known as Boystown's friendly neighborhood tavern, or dive bar, or "wrinkle room," depending on who was talking. In 2014, it was sold to the owner of Little Jim's neighbors the Ram and Cupid's Treasure. The new owner decided to keep Little Jim's traditional atmosphere. Even the young customers, manager Frank Riccio says, wanted Little Jim's to stay the same. (Courtesy of Gerber/Hart Library and Archives.)

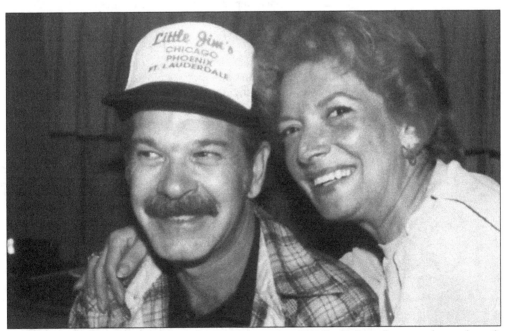

Little Jim Gates hangs out with Adrene Perom, owner of Big Red's, a gay bar once located north of Little Jim's. As his hat indicates, Gates wound up with three locations for Little Jim's. He also ended up going into business with his lover, Big Jim Slater. (Courtesy of Gerber/Hart Library and Archives.)

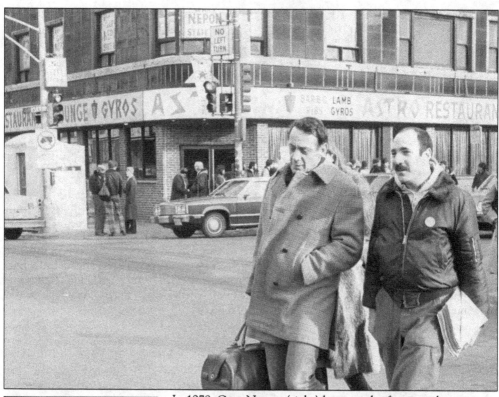

In 1978, Gary Nepon (right) became the first openly gay man to run for office in Illinois. Harvey Milk (left), who the year before had made gay history by winning a seat on the San Francisco Board of Supervisors, came to Chicago to help Nepon's bid for state representative. In the background is Nepon's campaign office on the second floor of the Astro Restaurant, 2745 North Clark Street. (Courtesy of Gerber/Hart Library and Archives.)

Gary Nepon's candidacy for state representative was a long shot from the beginning. The *GayLife* newspaper opposed him, and the incumbents (there were two under the system then) had voted for gay-rights legislation. (Courtesy of Gerber/Hart Library and Archives.)

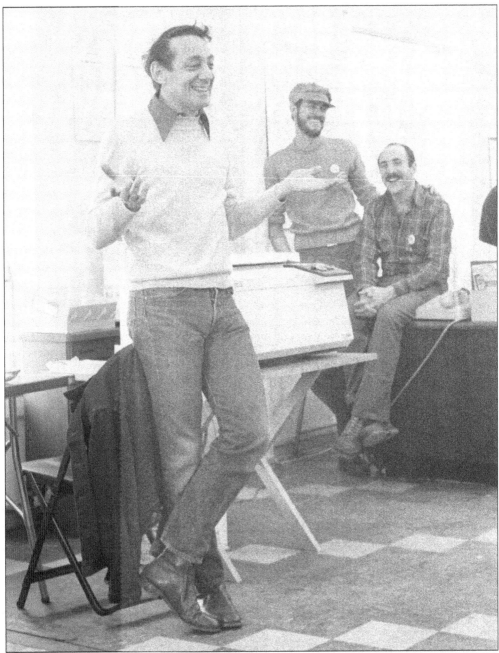

Harvey Milk (left) visits Gary Nepon's campaign office in 1978, with Nepon's lover, David Barrett (in hat), listening. Nepon broke new ground but lost his race for state representative. He later died of AIDS. Milk was shot and killed later that year. (Courtesy of Gerber/Hart Library and Archives.)

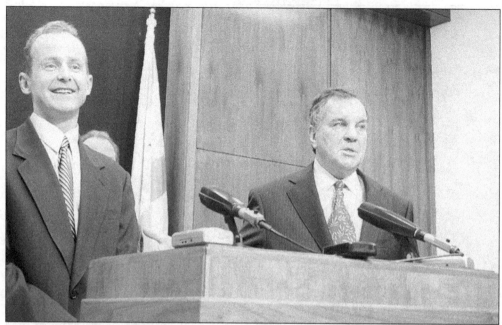

The political struggles of gay Lake View culminated in Mayor Richard Daley's 2002 appointment of Tom Tunney (left) as 44th Ward alderman. Tunney, the owner of Ann Sather and former chair of the Illinois Restaurant Association, was the first openly gay Chicago alderman. He won the popular election in 2003 and remains alderman. (Courtesy of Tracy Baim/*Windy City Times*.)

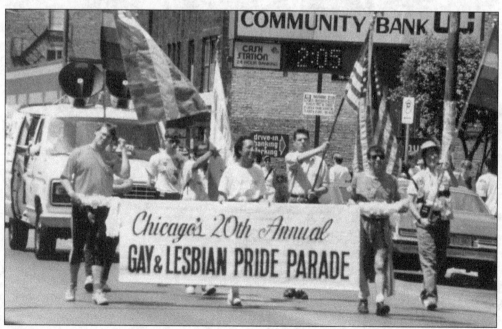

Gay pride marchers in 1989 mark the 20th anniversary of the parade, which began in Washington Square Park on the Near North Side. Then, 150 marchers listened to speeches in the park, walked to the Daley Center, and chain-danced around the Picasso statue chanting "gay power to gay people." (Courtesy of Gerber/Hart Library and Archives.)

AIDS activists pull no punches with their 1989 float that compares quarantining of AIDS sufferers with a Nazi concentration camp. The float links Cardinal Joseph Bernardin of the Catholic Church, who fought the city ordinance that shielded gays, to Adolf Hitler. On the truck's side are pictures of former president Ronald Reagan and Illinois legislator Penny Pullen, a conservative who served on Reagan's HIV commission. (Courtesy of Gerber/Hart Library and Archives.)

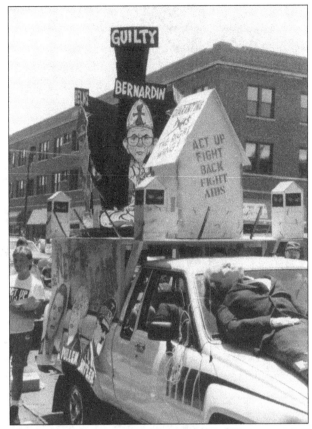

What would a gay pride parade be without a pose? And a photographer to shoot someone else posing? Here they are in 1991. (Courtesy of Gerber/Hart Library and Archives.)

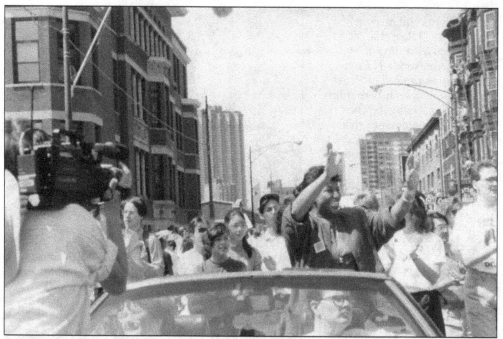

Carol Moseley Braun campaigns for US Senate during the gay pride parade on Broadway in 1992. The Democrat won an upset victory and later was inducted into the Chicago Gay and Lesbian Hall of Fame. (Courtesy of Gerber/Hart Library and Archives.)

The boys of Boystown watch the 1991 pride parade underneath a well-placed ad for Leslie Nielsen in *The Naked Gun 2½: The Smell of Fear*. (Courtesy of Gerber/Hart Library and Archives.)

Wave! It is the Chicago Eagle float. The leather bar, now closed, was the home of the International Mr. Leather competition started by gay activist and entrepreneur Chuck Renslow. The bar was noted for its backroom dress code, which required people to wear leather or a uniform. (Courtesy of Gerber/Hart Library and Archives.)

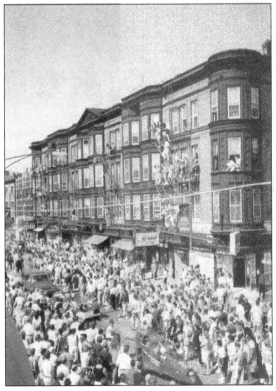

The pride parades grew in popularity until the crowd numbered more than 100,000 in 1992, when this photograph was taken. The photographer was on the roof of the old Woolworth's on Broadway, south of Melrose Street. People are hanging out of windows, a far cry from the first parade of 150 people. In 2013, parade attendance topped 1 million. (Courtesy of Gerber/ Hart Library and Archives.)

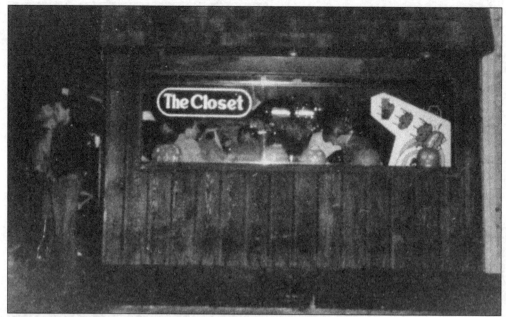

The Closet is one of Lake View's oldest gay bars—if one even considers it a gay bar. It holds the rare status of being a place where, for decades, gays and straights, men and women, have mingled. This photograph was taken around Halloween 1982, four years after Judi Petrovski and Rose Pohl bought the Closet. They still own the establishment. It has lost its wood facade but is still wedged into a storefront at 3325 North Broadway. (Courtesy of the Closet.)

In the 1970s, the Closet was a tiny folk bar named Digby's. When a lesbian bartender started working Sundays, it became a gay bar, although only one day a week at first. The owner asked customers to rename the establishment, and perhaps with a pun in mind, they called the diminutive space the Closet. (Courtesy of the Closet.)

Eight

WRIGLEYVILLE

Maybe it is fitting that a seminary once stood at Clark and Addison Streets. The ballpark that replaced the religious school has become a holy place for baseball fans, especially since the Chicago Cubs won the World Series in 2016.

Baseball on Addison Street, so fabled now, started inauspiciously. The Chicago Whales of the Federal League debuted at the new Weeghman Field in 1914. Neither the team nor the league lasted long. Undeterred, Charles Weeghman, a luncheonette-chain owner, bought the Cubs, who already existed, and put them in his park in 1916.

The Cubs' purchase by gum magnate William Wrigley Jr. in 1920 set in motion the changes that would make the park what is today. He started by switching the name to his own, and topping the park with another deck. In 1937, the owner made three improvements from which the team has reaped benefits ever since. He built bleachers, installed the green scoreboard now so beloved, and added ivy-covered outfield walls. The idea was to make Wrigley Field more of a park than a stadium.

The idea worked. Wrigley Field's stature as a picturesque ballpark in a neighborhood turned into its distinguishing feature. The contrast was sharp as teams in the 1970s built hulking concrete stadiums surrounded by parking lots. Wrigley stayed humble, embedded in what until recently was a typical North Side community. As late as 1990, the area was only just beginning to be called Wrigleyville, and Clark Street seemed to have as many Thai restaurants and reggae bars as it did sports-themed establishments. All that soon would change.

Double-storied sports bars now dominate Wrigleyville. The neighborhood hops even during road games. The Cubs' ambitious owners, the Ricketts family, are supercharging Clark Street with more development. Movie theaters are in the works. At the same time, the team has restored the ballpark to its period look, with terra-cotta and ornamental grills. On one more block of East Lake View, the past and future will spar.

THE SEMINARY GROUNDS LOOKING NORTH-WEST.

Welcome to c. 1900 Wrigleyville. This is the Chicago Lutheran Theological Seminary, seen in a view looking northwest from Sheffield Avenue. The seminary occupied the land where Wrigley Field stands today. In 1910, the seminary moved to Maywood. The ballpark was still to come. (Courtesy of archive.org.)

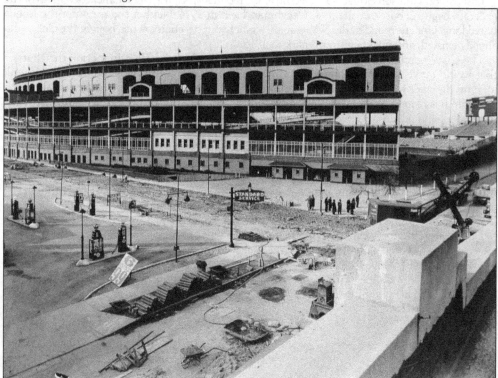

Here, men work on Addison Street and Sheffield Avenue. The photographer is shooting from what is now the gigantic Starbucks near the corner, in what once was Hi-Tops bar. The Standard gas station later became a 7-Eleven, which was recently torn down. (Courtesy of Chicago Cubs.)

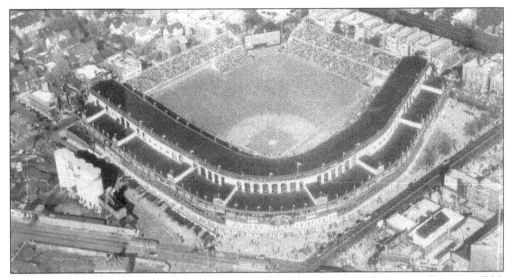

This aerial shot shows Wrigley Field during the World Series against the Detroit Tigers in 1935. Much of the park and the surrounding buildings look like they do now. One obvious difference from today is the coal silos. Five large silos stand just west of the park, where later a car wash and Yum Yum Donuts operated. West of Clark Street, there is another coal yard; it closed three years after this photograph was taken. (Courtesy of Chicago Cubs.)

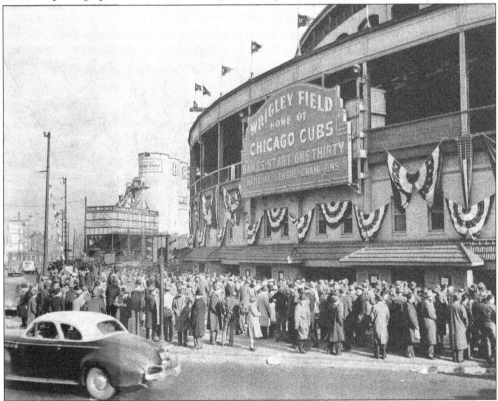

This photograph is undated, but given that the sign boasts of a National League championship, it might have been taken after the Cubs won the 1945 pennant. (Courtesy of Chicago Cubs.)

The Milwaukee Road rail line once ran north through the middle of Lake View, skirting the west edge of Wrigley Field and serving coal and lumber yards. (Courtesy of Chicago Cubs.)

Ladies wore only their best when they came out to root for the Cubbies. The Cubs sponsored Ladies Days for decades, and the women-get-in-free events enjoyed great popularity. One Ladies Day famously resulted in tens of thousands of female fans breaking turnstiles in a scramble for seats. (Courtesy of Chicago Cubs.)

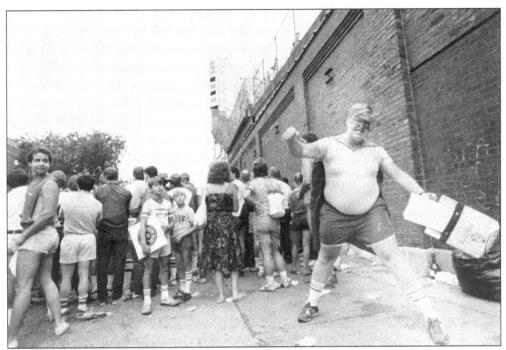

Fans wait in line outside the bleachers in the 1980s. The out-of-shape superhero is sporting a mask with a Cubs logo on it. (Courtesy of Chicago Cubs.)

Let there be light! Fans crowd Waveland Avenue on July 25, 1988, to see lights turned on at Wrigley Field. The team, the last to play all day games, had campaigned for lights for six years and inspired so much enmity that the city banned night games. The team prevailed nonetheless. This night was only for batting practice; the Cubs did not begin their first night game until August 8. (Courtesy of Sulzer Regional Library, Chicago Public Library, RWK 9.10.)

Bernie's bar is a Wrigleyville institution. In 1981, Bernie's welcomed two men to the Cubs and the neighborhood, announcer Harry Caray and general manager Dallas Green. Bernie's was named after owner Bernie Dillman, who grew up on the second floor of the tavern at 3664 North Clark Street. (Courtesy of Bernie's Tap & Grill.)

Cubs announcers Bob Brenly (left) and Thom Brennaman (right) pose with Linda Dillman about 1990. Linda and her husband, Donald Dillman, who was Bernie's son, bought the bar in 1981. (Courtesy of Bernie's Tap & Grill.)

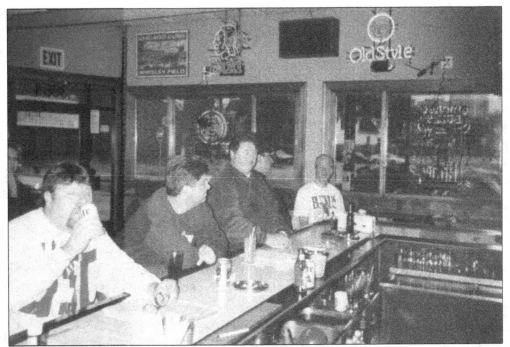

Fans quench their thirst at Bernie's in the 1980s. In Bernie's early days, there were four bars near the ballpark, Linda Dillman recalls. Now there are more than 50, but Bernie's survives. (Courtesy of Bernie's Tap & Grill.)

The modern, spiffed-up Bernie's features a bar on the second floor (where the Dillman family once lived) and an upscale sign. Bernie's daughter-in-law Linda Dillman never tires of running the tavern. "I just like it," she says. "I love baseball." (Photograph by author.)

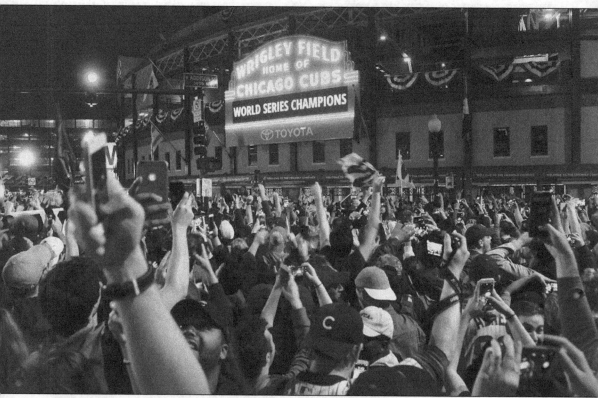

November 2, 2016, is a date that will live in Chicago Cubs history. Joyful chaos reigned in Wrigleyville the night the Cubs won the World Series, even though the game was in Cleveland. Cover prices at bars soared to $100, fans scaled light poles, and the police closed the intersection of Addison and Clark Streets. After the final out, illegal fireworks erupted and strangers hugged. One fan said he had to remind himself to breathe: "The whole thing is so intense." Other fans resorted to hyperbole. "It's like there's a tectonic shift in the universe," one said. Another exclaimed: "This is history!" (Courtesy of Craig Newman.)

Nine

MEMORIES OF
EAST LAKE VIEW

Many photographs of East Lake View remind people of a favorite old restaurant, how a street corner once looked, or where their elementary school stood before the wrecking ball swung. But no one alive remembers the dawn of the 20th century, with sights like the gigantic Waller House and the little dummy railroad. Yet turn-of-the-century photographs perhaps are more important than any others.

Pictures of East Lake View 100 years ago depict a world that is lost today. Spaces are vast, streets are empty, and crowds are few. To think there was room to put a Ferris wheel near Clark Street and Diversey Parkway! East Lake View of today is jammed with people, buildings, and cars. Citizens move faster, and speed gives the gift of convenience but robs many of time to think. A 1905 postcard of Sheridan Road shows only two motorcars and two carriages on the whole thoroughfare, with two men strolling by.

The old photographs depict placid scenes, but Lake View was changing. The community was originally settled by Conrad Sulzer, who was followed by truck farmers. Industrial workers, drawn by factories like Illinois Malleable Iron and Northwestern Terra Cotta, replaced the farmers. The area, Lake View Township, grew so populous that it incorporated as the City of Lake View in 1887. Overwhelmed by independence's cost, Lake View voted for annexation into Chicago after just two years. Little remains to remind people today of independent Lake View but the old Town Hall District police station, built on the site of the hall that housed the township government of Lake View.

What with all the change, it is heartening to see evidence of continuity. East Lake View has seen hundreds of thousands of people come and go, but the Heise family has lived in the neighborhood since the 19th century. On Fremont Street, a fourth-generation Bose lives in the family three-flat. At the Blarney Stone bar, American Indians gather from time to time, as they did 40 years ago, when their numbers were strong on Clark Street. Moviegoers can still go to the Century, just as their grandparents did. No matter how much East Lake View changes, its past keeps calling.

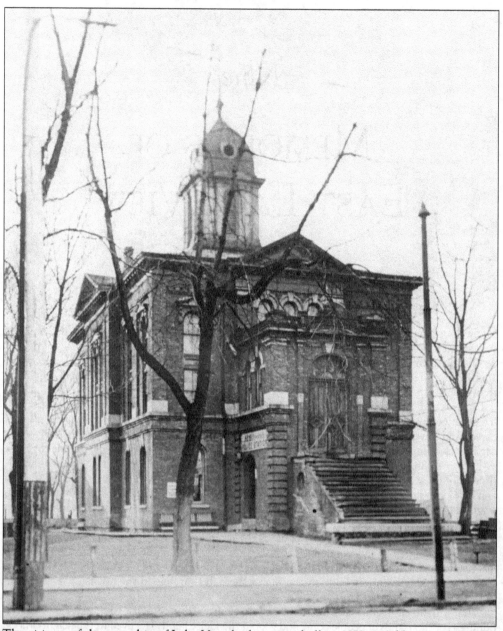

The citizens of the township of Lake View built a town hall in 1872 at Addison and Halsted Streets. After Chicago absorbed Lake View, the building was used as a police station. One can see the police sign to the left of the stairs in this 1890s photograph. This building was replaced in 1907 by another structure, which was used as the Town Hall District police station until 2010. (Courtesy of Sulzer Regional Library, Chicago Public Library, RLVCC 1.192.)

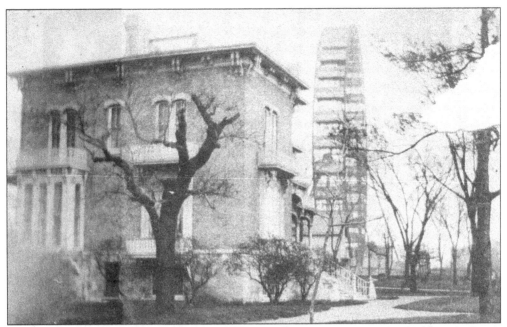

Lake View used to be a lot more fun, especially when it had its own Ferris wheel. This is the Busch house at the southeast corner of Clark Street and Diversey Parkway, around 1900, with the wheel behind it. The wheel was moved from the 1893 World's Fair on Chicago's South Side. Lake View lost the wheel when it moved once again, this time to St. Louis for the 1904 fair. (Courtesy of Sulzer Regional Library, Chicago Public Library, RLVCC 1.1834.)

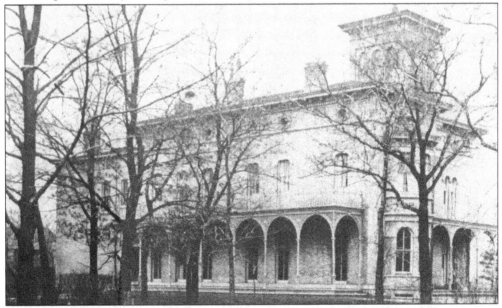

Welcome to Buena House, and what a house it was. This Kentucky-style rambling manse at Sheridan Road and Buena Avenue was the home of J.B. Waller, a Kentuckian who hit it big in Chicago real estate. He founded the suburb of Buena Park on the land he owned around this house. With his family, he was said to have owned half of the city of Lake View. (Courtesy of Lake View Presbyterian Church.)

This c. 1905 postcard of Sheridan Road, with a view likely looking from Grace Street, shows the vista that gave Lake View its name. Note how deserted Sheridan Road is. (Courtesy of Garry Albrecht.)

Lake View's current-day landmarks already are present to a great degree in this c. 1930 postcard of Belmont Harbor. One can see the Chicago Yacht Club on the left. Behind it is the Hotel Belmont at the southwest corner of Belmont Avenue and Sheridan Road, with familiar high-rises to the right. Since golfers are present, this postcard must depict the northern tip of the old Diversey golf course, where the driving range is now. (Courtesy of Garry Albrecht.)

A wicked storm swept boats off their moorings and onto the shore at Belmont Harbor. In the background is the Chicago Yacht Club. This photograph is undated. (Courtesy of Garry Albrecht.)

Two L trains stop at Belmont Avenue on March 7, 1931, in a view looking north. One train is heading north, possibly to Howard Street. The southbound train is heading for the Loop, where it will turn around and head to Ravenswood and Albany Park, as its sign reads. (Courtesy of Chicago Transit Authority.)

Even in 1935, Chicago was trying to untangle rush hour. This shows a reversible-lane scheme where Lake Shore Drive and Sheridan Road came together near Belmont Avenue. In the morning, eight lanes were opened going south, with just two north. In the evening, the lanes were reversed. (Courtesy of Garry Albrecht.)

The beautiful stone-and-brick building at the southeast corner of Addison Street and Broadway once housed a drugstore, seen here with its ads for Palmolive and Canada Dry. This photograph is undated, but in the 1920s, it was the Edward F. Wirth pharmacy that occupied the corner space. (Courtesy of Joe's on Broadway.)

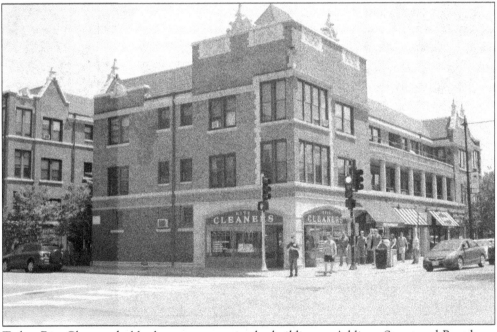

Today, Ritz Cleaners holds the corner spot in the building at Addison Street and Broadway. Running south, the next two storefronts are Joe's on Broadway and Angelina Ristorante. (Photograph by author.)

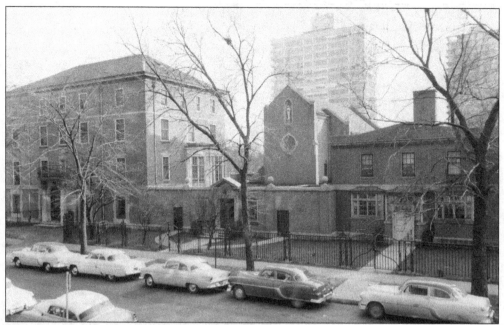

The Society of Helpers, a Catholic women's order, moved its American headquarters to Lake View in 1943, buying a mansion (left) that was a reputed gambling hall on Barry Avenue just west of Lake Shore Drive. The order also built a beautiful chapel (right) that stood for many years. (Courtesy of Society of Helpers.)

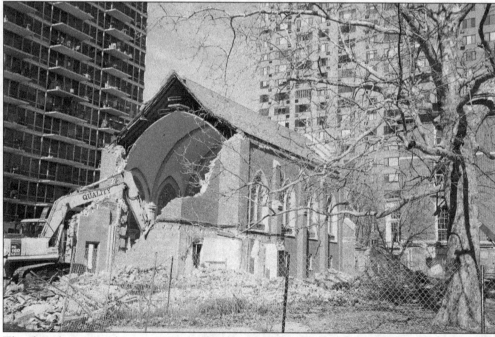

The chapel was torn down in 2008 for development after the Society of Helpers decided to sell. The sisters also sold the mansion, which by that time housed a home for AIDS patients. The home's head protested, but the sisters said they needed the money—$21 million for the whole property—to care for aging members of the Society of Helpers. (Courtesy of Susanne Schnell.)

The House of the Good Shepherd, 1126 West Grace Street, is a battered women's shelter with roots in the 19th century. This photograph was taken in 1910, when the organization was already 51 years old. House of the Good Shepherd also was known for decades to Cubs fans—it owned the lot where a nun would park people's cars. (Courtesy of Sulzer Regional Library, Chicago Public Library, RLVCC 1.96.)

This was 3639 North Broadway in 1971. Matronly women chat around the corner from a slit-windowed tavern and a Hamm's beer sign. Lake View had a very different look before gentrification. Today, the site is occupied by Byline Bank, which changed its name from North Community Bank in 2015. (Courtesy of Samuel Malkind.)

STAGEBILL

LEE BOUVIER
"The Philadelphia Story"

The Ivanhoe, a restaurant and theater, was one of Lake View's beloved institutions. The Ivanhoe, housed in its castle-like edifice at Clark and Wellington Streets, dated to the 1920s. Few photographs of the Ivanhoe remain, but this 1967 program shows Jacqueline Kennedy's sister starring in *The Philadelphia Story*. Lee Bouvier bombed, but the Ivanhoe featured better performances by the likes of Rita Moreno, Christopher Walken, and Jessica Tandy. (Courtesy of Garry Albrecht.)

The Ivanhoe laid the medieval charm on thick. But, as the matchbook says, the Ivanhoe really did have catacombs, and they are now the cellar of Binny's Beverage Depot. Binny's, which holds tastings in the catacombs, took over the restaurant in 1978 and the theater in 2001. (Courtesy of Garry Albrecht.)

The Heises are one of Lake View's oldest families, having lived in the neighborhood since the 19th century. Dora Heise-Kropifko poses with her baby son, Tony, near their home at 1133 West Patterson Avenue in the 1970s. Today, she lives with her husband, Arthur Kropifko, on the same block. (Courtesy of Dora Heise-Kropifko.)

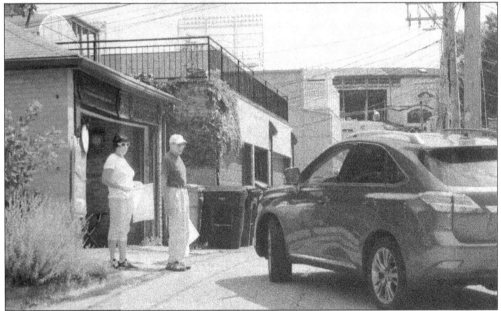

Dora Heise-Kropifko and her husband park cars during a 2016 Cubs game in the alley that runs between the 1100 blocks of Patterson and Addison Street. They handle parking for neighbors on their street, splitting the $55 per car fee. It is one way to afford an increasingly expensive neighborhood, and brings her full circle; 50 years ago, she parked fans' cars for $1.25. (Photograph by author.)

Blink an eye, and Lake View changes—but not Melferd Bose. He and his family like to stay in the same place. The lifelong Lake Viewer lives in this building at 3521 North Fremont Street, the same one that his grandparents bought in 1920. His son lives in the building, and his daughter live next door. Old Lake View lives! (Photograph by author.)

Melferd Bose's mother once lived in this shingled two-flat at 3518 North Reta Avenue, one block from where Bose lives now. Her home, predictably, was torn down for development. (Courtesy of Melferd Bose.)

The Blarney Stone boasts an Irish name, an Irish owner, a picture of John F. Kennedy—and American Indian customers. A woman from county Mayo, Bridie Nolan Krystof, opened the bar in 1970 at Clark Street and Sheffield Avenue when many American Indians lived nearby. Some bars would not serve them, but Blarney Stone did. (Photograph by author.)

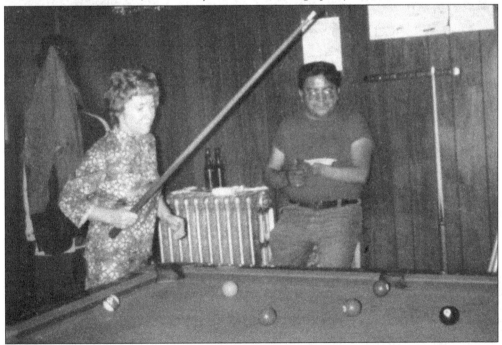

When Bridie Krystof (left) ran Blarney Stone in the 1970s, Clark Street drew a rough crowd. The American Indian customers always protected Krystof. "She treated them with respect. They treated her with respect," said her son, Gerald Krystof. (Courtesy of Blarney Stone.)

Donna Miller worked at Blarney Stone for two decades, until about 2010. Miller, a Chippewa from Wisconsin, was long a fixture behind the bar. There are few American Indians left in Lake View, but some still patronize Blarney Stone. (Courtesy of Blarney Stone.)

Blarney Stone saw its share of good times, but in the early days, closing time could bring trouble. Appalachian migrants hung out at a bar across the street, recalls Blarney Stone worker Danny Webb. When the two taverns closed, their customers squared off in the street. The American Indian customers wielded broken bottles; the migrants had knives. (Courtesy of Blarney Stone.)

The most famous Lake View American Indian must have been Scott T. Williams, known to Chicagoans as Chief Thundercloud. An Ottawa from Michigan, he lived near Clark Street and Newport Avenue in the 1950s. Williams appeared in his headdress at downtown Thanksgiving celebrations and was a regular at the old Olson Rug Company park and waterfall. His fame extended beyond Chicago. He is credited as the voice of Tonto on *The Lone Ranger* radio show. (Courtesy of findagrave.com.)

Hilda Marietta Williams, daughter of Chief Thundercloud, grew up in Lake View. Little Fawn, as she is known, kept up her father's tradition of celebrating American Indian heritage by working at the American Indian Center of Chicago. She now lives in Michigan but recently traveled to suburban Chicago to attend a gathering of American Indian veterans, as seen in this photograph. (Photograph by author.)

Bob Geraghty cleans up in 2001 at Gill Park, located at Broadway and Sheridan Road. Geraghty, the former park supervisor and a longtime Chicago Park District worker, retired in 2016. (Courtesy of Gill Park.)

Girls play double Dutch at Gill Park in the 1990s. The park was named after Lake View luminary Joseph Gill. Born in the neighborhood in 1885, Gill served as 46th Ward committeeman for more than 60 years. He died in 1972, just as the Chicago Park District was planning a field house at 825 West Sheridan Road. The field house was built and named after him. (Courtesy of Gill Park.)

The Century mall shines in the 1980s at 2828 North Clark Street. It was built in 1925 as the Diversey theater, a 3,000-seat vaudeville venue. Balaban and Katz turned it into the Century movie theater, but it fell on hard times in the 1970s. It became a vertical mall, but in 2000, it was changed back into a movie theater. Now, there are seven screens, as well as shops. One thing remains: the Century's beautiful white-pilastered facade. (Courtesy of Sulzer Regional Library, Chicago Public Library, RLVCC 1.96.)

Visit us at
arcadiapublishing.com

..